The Concrete Wicket in B&W

2022 Season in Review
Pictures & Words by Liam Leroux

The Concrete Wicket
2022 season in Review

The usual legal fidgy widgy about the author's rights
and so forth might apply here. I don't know. Anyone
who has any advice about the publishing business
and wants to help out by all means let me know.

@theconcretewicket on IG
@concretewicket on Twitter
theconcretewicket@gmail.com

Shot and compiled in Edmonton, Treaty 6 territory

Dedicated to His Majesty,
Sir Oliver Snotsalot,
the cat who makes a lot of snot

The Concrete Wicket

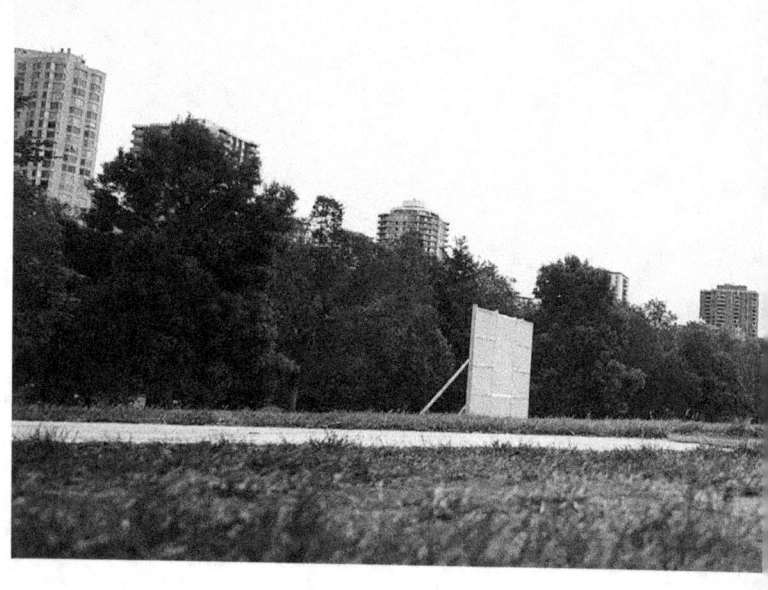

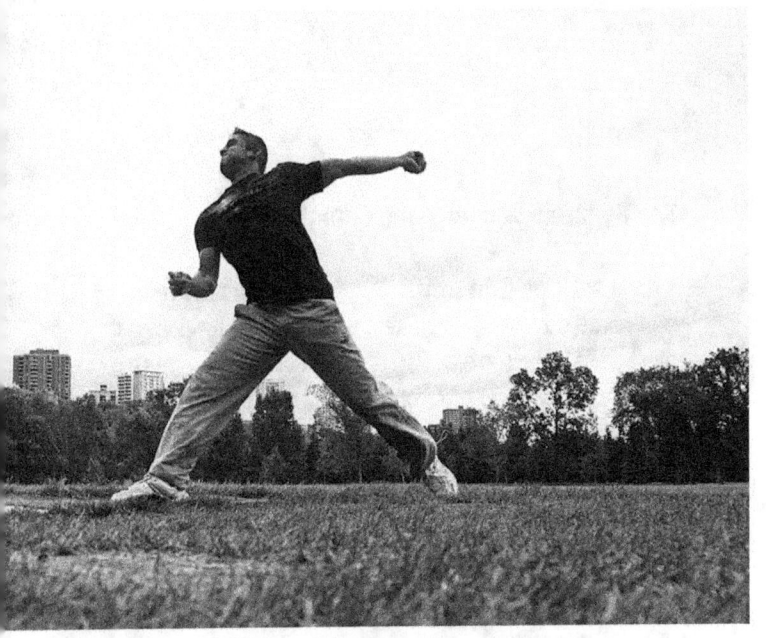

& the Chainlink Fence

The Concrete Wicket & the Chainlink Fence

This was my first unwieldy idea for the title of a magazine devoted to cricket, inspired by the first set of pictures I ever took at VP. It's sort of impossible to overstate my level of excitement when I first discovered the existence of Victoria Park Cricket Ground. One fine June day, I was walking along the usual spot, that nice promenade on 100 Ave, overlooking the golf course in the valley. And there, for the first time, I spied the batting screen by the Weaver Memorial End. Or perhaps it was the first time I'd seen this screen and understood what it means. This field was not part of the golf course, but was, in fact, a cricket ground! I raced down the steps into the valley, camera in hand and ran around the boundary of this gleaming emerald oval in much the

Sport is, and always has been, important to me. Sure there was, briefly, a period in high school where my interests extended no further than Star Trek, the Simpsons, & Stephen King. But as this type of teenage disgruntlement is common enough I won't spend further time on it. Point is, the first thing I read in the paper after the comics was the sports section. The main thing I watched on the news were the sports highlights. In a pub quiz I'm always most useful in the sports rounds. I know the basic rules and scoring systems for most of the games around the world known as football (football, soccer, Gaelic, rugby union & league, and, to a lesser extent, Australian rules, which no one really knows or understands) basketball, racquet sports, baseball, hockey, volleyball, etc. But I'm also an old middle aged guy now. How reliable is my memory? Was there zero coverage of cricket in the paper when I was younger or did I just gloss over it the same way I ignored the business pages?

I'm certain, given how much I loved the Star Wars movies (as a child) that, had I been exposed to cricket at the same age I would have been just as enamoured with the game as I am now. The cricket batter, of all

the sports I have ever paid any attention, is the one who most closely resembles a light sabre guy. But far from being exposed to cricket as a child there appears to have been, historically, a subtle, society wide campaign against cricket in North America. Some of this is perhaps merely a practical matter; cricket requires a sort of cultural infrastructure to exist. Like, the ease with which a five-a-side footie match can be organised is significantly less complicated than the requirements for a cricket match. It took a long time to develop an environment in which a group of 22 men could play a ball and stick game over FIVE FULL DAYS and that five day match would be only one match of a five test series. And there might be two separate series in a year in completely different hemispheres. Test match cricket is an enormous commitment. So, though cricket might have been Canada's national sport in 1867, it seems clear hockey would always have become the basic cultural staple of a frozen tundra country's basic sports diet. Even so, I learned more than just the rules for hockey as a kid. We were even taught the rules for water polo at one point. Why is it we're learning the rules to water polo in public school Phys Ed class but we are not even taught of the existence of cricket?

My first guess in a country like Canada is racism which is a hot button topic and gets people's backs up. But Canada is so multi ethnic they say, open and tolerant democracy they say, etc. & so forth, they say. Besides the fact the entire structure of the governing system is a set up of British colonialism and that all the land that isn't owned by some large multinational corporation is called "crown land" instead of indigenous land, there's just all the racist people that live here. In the 1999-era office of the Calgary Herald, when I briefly worked for that paper, there was a framed photo of a burning cross hanging on the walls of the editorial department. This very large and public cross-burning with all the attendant pointy masked white fascists happened in 1990, the same year as the Oka crisis. A crisis precipitated by the Ontario premier calling in the army because the Mohawks objected to a golf course being built on their home. Premier Mike Harris quoted saying to the OPP, "I want the fucking Indians out of the park." These are just a couple of the big, national scandal level examples available to view in easily accessible archives (a quick Google search). Canada therefore, being a racist colonial project, might have shied away from the sport of cricket after CLR James

wrote his seminal memoir, Beyond A Boundary (Hutchinson, 1963). Here, James documents the central role cricket played in the anti colonial rabble rousing which occurred across the Caribbean in the 20th century and maybe Canada didn't like that sort of juice. This is all pure speculation on my part. Sometimes people think it's too easy to just blame every bad thing on racism but like Malcolm X said, "You can't have capitalism without racism," and Canada proudly declares itself a capitalist nation, so I don't know. Maybe it's not racism at all. Maybe it's just because they don't like cricket and think it's boring. But no, that's absurd. They'll show a full four day golf tournament on television all weekend. You can't tell me a cricket match isn't worth at least a highlights package. It's visually spectacular. Maybe they think the game is too complicated but that's not true either.* The game is, in fact, rather simple. It's the scoring that's complicated. If this seems like inconsequential semantics it's probably because you haven't ever watched a match. Every over of cricket has a person on one team throwing a ball (I know it's not called throwing in cricket but that's the unnecessary semantics part) a bowler delivering a ball to a person on the opposite team with a bat who tries to hit the ball and a bunch of people stand in a field and try to catch the ball.

This happens six times then they switch ends and start a new over. I don't see any reason why a person interested in baseball or basketball or golf wouldn't also be interested in cricket. If the scoring is too complicated to immediately grasp, then that is the responsibility of well paid media professionals. I learned a lot from radio and television broadcasters in England explaining to me what happened and showing me graphs and scoring charts. But the actual game is pretty easy to grasp immediately. Learning the rest has taken me decades and I've still plenty long way to go, but sure, that's the fun.

Whatever the reasons might be, I grew up in Canada knowing nothing of cricket.

By the time I started my first full-time staff newspaper photographer job in England I was under the mistaken impression that cricket was an old fashioned game exclusively for the drunken aristocratic set. This arcane pastime surely had no relevance to modern existence, I quite smugly and confidently thought. I distinctly remember being annoyed by my early cricket jobs for the sports desk. Annoyed because I would get lost on the way to the ground, I'd have no idea what was going on in the middle of the pitch, and my editor would just tell me all my pictures were bad.

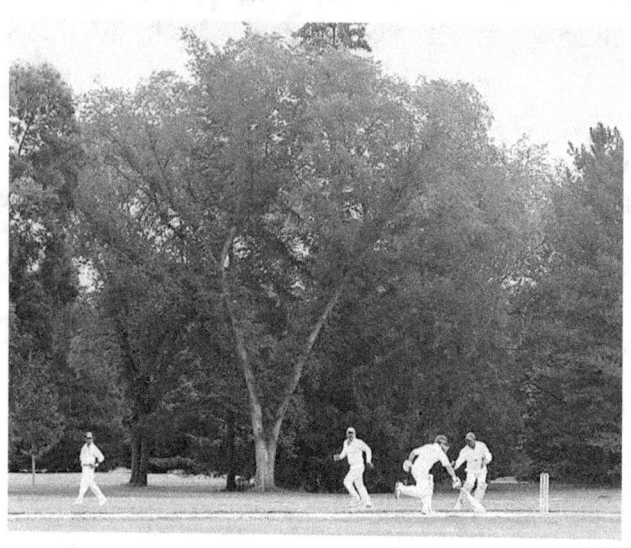

(Here look now, I know I said earlier - the game is simple, it's the scoring that's complicated - so what's this about not knowing what's going on in the middle of the pitch? Understanding the game as a spectator and understanding the game as a professional photographer with a grumpy English editor are entirely different circumstances. Until I learned the rhythm and timing of the game I never pressed the little shutter button at the right moment. So when my editor complained that my pictures were bad it's because my pictures were bad. But I already knew that so I didn't appreciate his beetroot face shouting abuse.) However, despite all my initial learning struggles, by the end of my Oldham Chronicle tenure the cricket will have become my favourite weekend assignment.

After I left the Chron a series of fortunate and unfortunate events left me to conclude I had no future as a photographer and I was reasonably convinced I was out of the media business forever. But then, on that fateful sunny June day more than a dozen years ago, record scratch wait, 12 YEARS?

What took so long?

I'm not a fast moving guy. I was still playing Sunday league soccer at an age where every year got more difficult and more time was required for recovery leaving less time for any other activities. Also I didn't have the right kit. Those first six shots I took at Victoria Park were on film. This project would have been fiscally impossible on film. I mean, sure in an ideal scenario a million worldwide subscribers would pay me one shiny Canadian nickel per match and I could afford to shoot every game on a Pentax 67 with an 800mm f6.3 ef lens on 120 roll film, using discontinued Fujichrome 400 sourced from dodgy underground markets like Jordan Belfort sourced quaaludes in Wolf Of Wall Street. But we all know very few of us live in ideal scenarios so I needed to find the right digital equipment which would suit my own expectations of pictures that look worthy of having a million viewers worldwide, even if those viewers haven't found me yet. And then the pandemic landed on these frozen shores throwing all my schedules into disarray. Suddenly, everything was possible.

I quit playing soccer. I found a Pentax K10d body and a 200mm f4 for $20. This is within the budget of even the most fiscally irresponsible of dishwashers and I am not the most fiscally irresponsible of dishwashers. I am fiscally neutral buoyancy most of the time and everyone once in a while I can find that I had not only $20 to buy that 200 mm lens but also $150 to buy an especially prized 50mm f1.4 and this was enough to get me started. Plus, Instagram

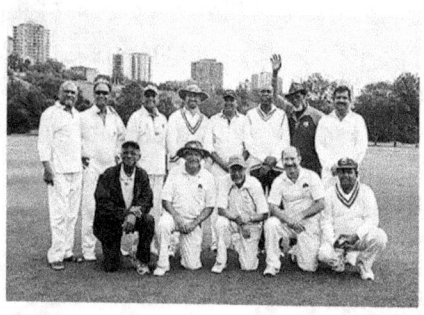

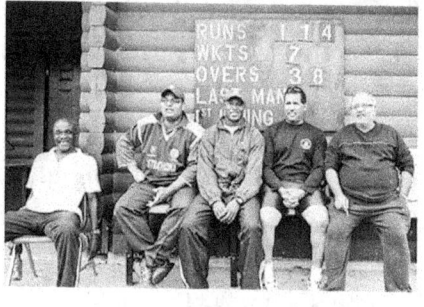

had subsequently been invented which meant I didn't have to figure out how to publish a printed magazine, I could just start a new social media account. An apparently common activity in our current era. And so, all of a sudden, at the beginning of June in the bizarre Gregorian calendar year of 2022 I found myself with the time and equipment necessary to start The Concrete Wicket. My new impossible mission, which I gratefully chose to accept, was to directly redress the paucity of cricket media in Edmonton. Should I ever get those million subscribers it just means I can do more of this. As it is, all I can promise to do is as much as I can to cover cricket in the city with as much commitment as all of the athletes who keep showing up and playing this beautiful game in this most incongruous of geographical locations.

And if you're reading this it means you bought my book and the only way I can express my gratitude is to keep taking more pictures. So look out for me at the grounds. I'll be there as much as I can!

Liam Leroux
Edmonton, November 2022

***Editor's note:** after listening to the Blindboy podcast about quantum mechanics I did have this thought about cricket.
 Soccer is your basic Newtonian physics. Attack one end, defend the other, the flight of the ball, even these crazy modern wobblers, all this stuff for the whole 90 minutes of the match essentially conforms to basic junior high school Newtonian understanding of movement.
 Cricket does more of the superposition quantum kind of stuff. It's attack and defense simultaneously. The fielding team is attacking the wickets and defending the run rate. The batters are defending their wickets but attacking for runs. Read a whole bit about the details Sachin Tendulkar put into thinking about his between wicket running, as important to him as his form in the crease, batting. And then, what a bowler like the late Shane Warne, for example, could do with the ball was suspiciously supernatural without a good modern understanding of quantum mechanics to ground it in real world science. Since quantum mechanics is widely understood as more complicated than Newtonian physics, well then that means if this newly considered analogy holds true perhaps it discredits my initial claim to the simplicity of the game?
 There is no reason to turn myself round inside Gordian brain knots, cricket is fun to photograph, it's no more complicated than that.

Victoria Park, 2010

Match action: Players, Fans, Miscellany

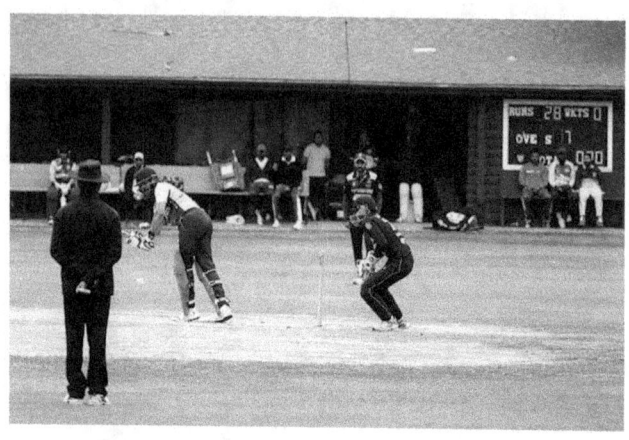

Greenfield 263/8 v 137/10 *Gujarat A* Elite 50 overs 5/06/2022, VP

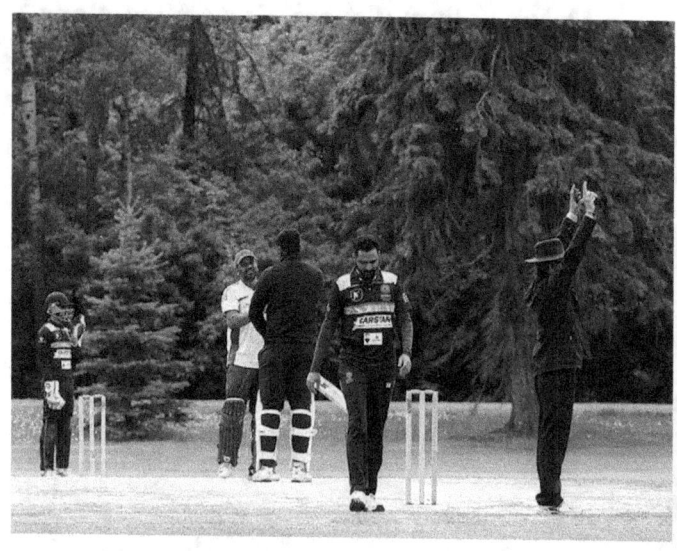

Previous Page: Greenfield man, waiting to bat.

Overleaf:

Millwoods A 138/9 *v* 132/9 *Challengers A* Elite T20 9/06/2022, VP

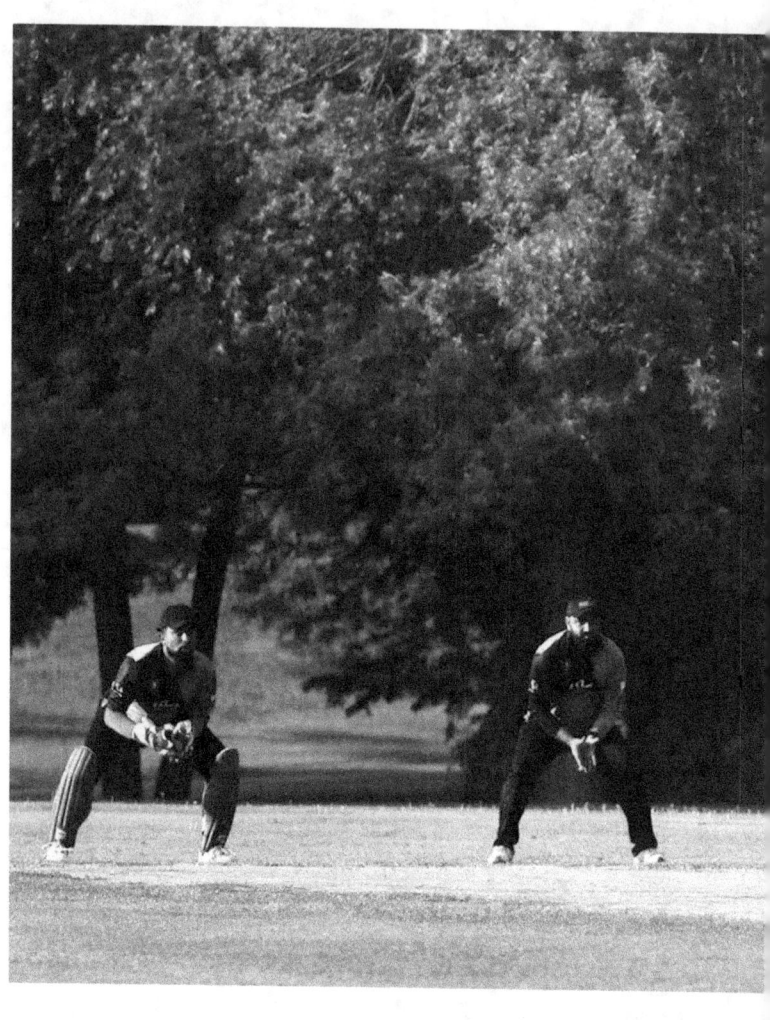

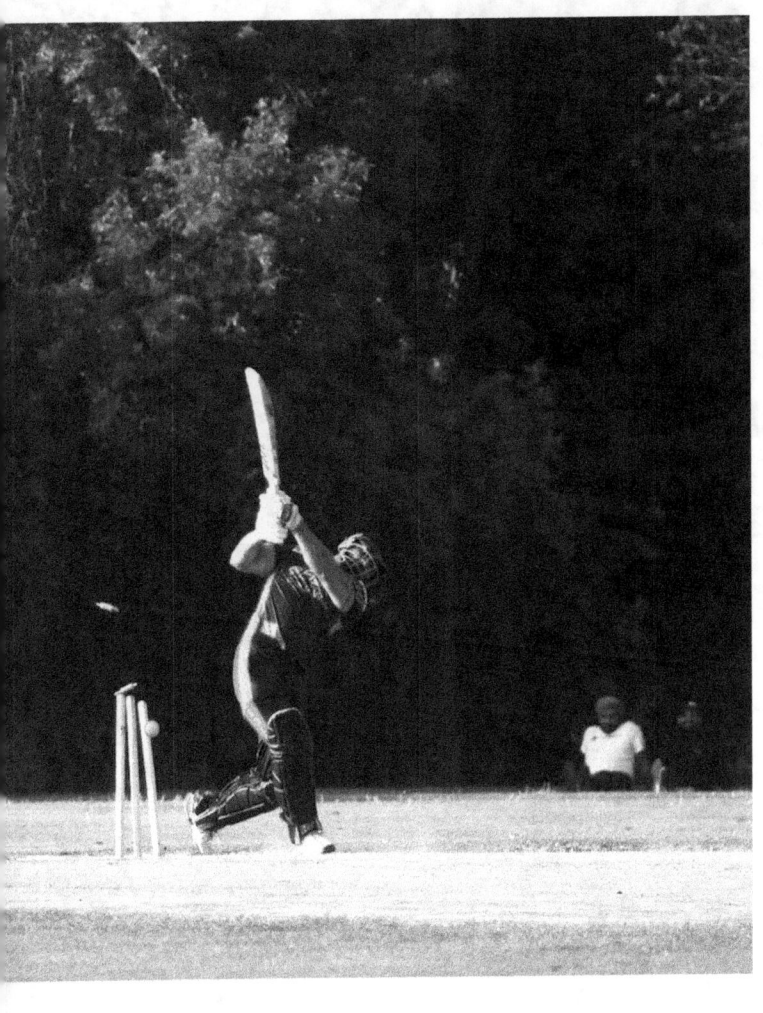

Opposite page:
Challengers A 234/10 v 194/10 Rising Stars A Elite 50 over 12/06/2022, VP

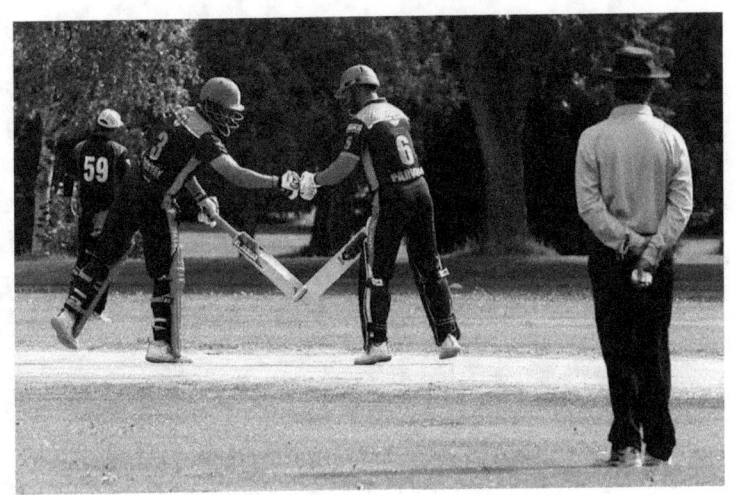

Kings XI A pose for a team photo after a 5 wicket victory vs *Rising Stars A* at Victoria Park, 16/06/2022

Gujarat A 135/9 v 116/10 *Shakti A* Elite 50 over 19/06/2022, VP

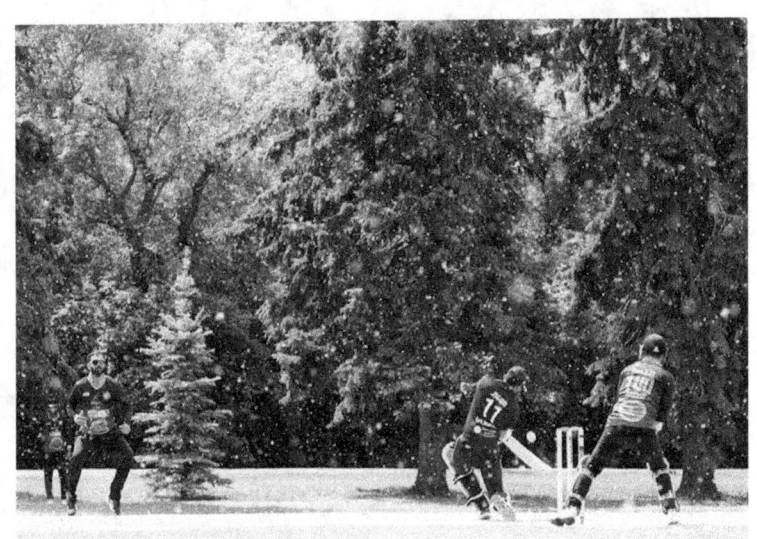

Opposite page: Punjab CC 123/9 v 125/3 Defiants - 1st Div T20 20/06/2022, VP
Defiants fielder turned around for the camera like, "Look what I caught!"

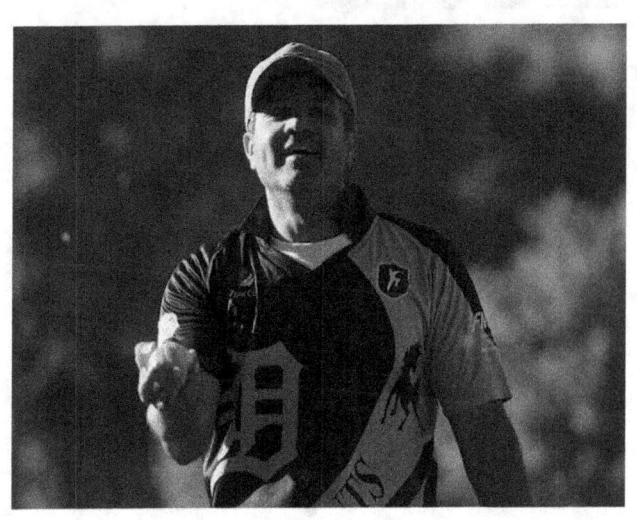

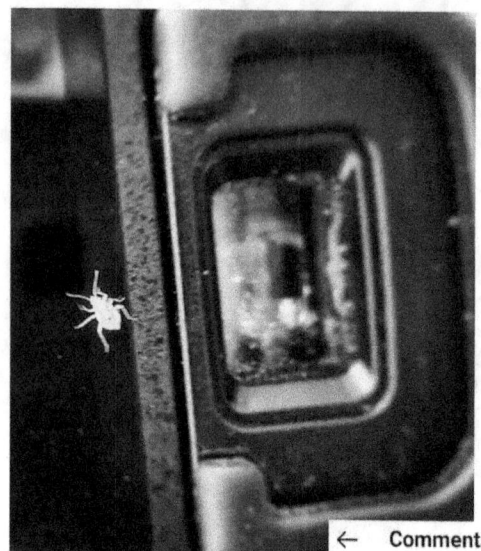

Tick, or no tick?

No tick!!!

What a fun game with surprisingly high stakes.

Comments

theconcretewicket 21w
Are there any entomologists following me on this page? Is it a tick? Did I have a lucky escape?

vmkaushik 21w
Im no entomologist, but my dad is. He says this is nymph(immature stage) of a plant bug!
1 like Reply

theconcretewicket 21w
@vmkaushik so not a tick? Relief! Thanks for checking for me!!!🙌
1 like Reply

vmkaushik 21w
It is not a tick !! Anytime 👍
1 like Reply

Ginny Memorial A 270/6 v 170/8 *Elites A* Elite 50 Over, 26/06/2022, VP
GM wins by 69 DL runs after 40.2 overs in the 2nd innings

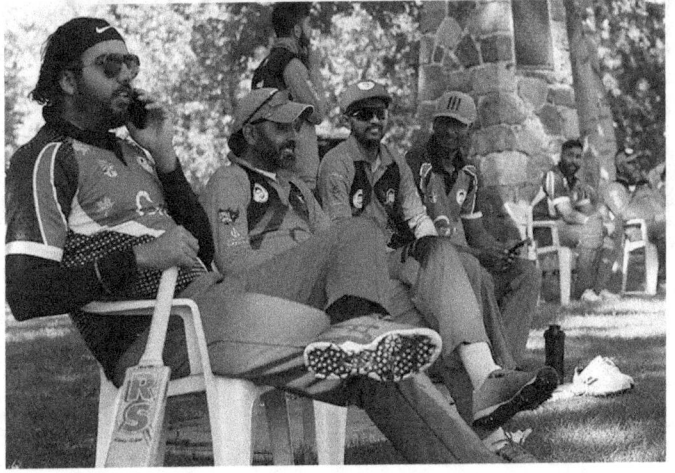

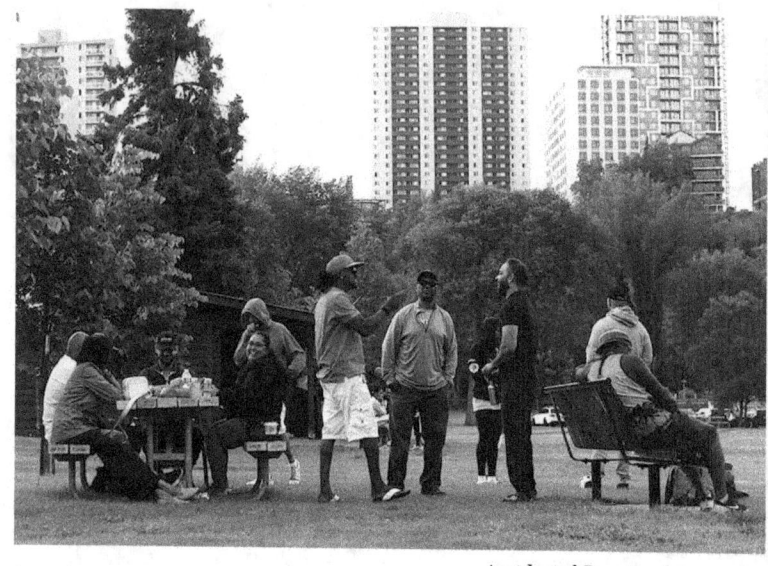

Accidental Renaissance
30/06/2022, VP

*Three generations of cricket fans
playing footie on the VP oval, 30/06/2022*

A day of sunshine and dragonflies, 10/07/2022

Cute little pitch inspection guy

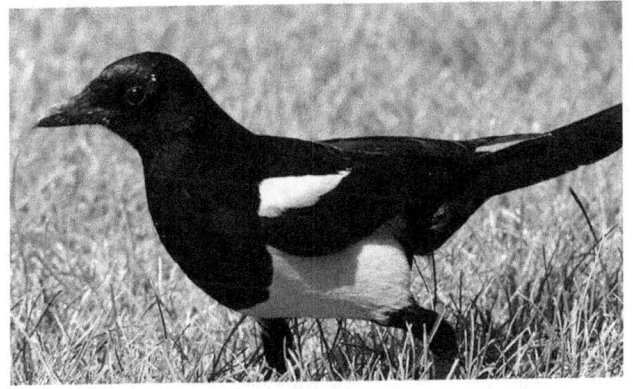

I heart dragonflies

Elites A 222/9

v

223/6 Challengers A

Elite 50 overs 10/07/2022 VP

Challengers A century-maker Sidhu Navdeep en route to scoring 110 not out.

(Dropped on 98!!!)

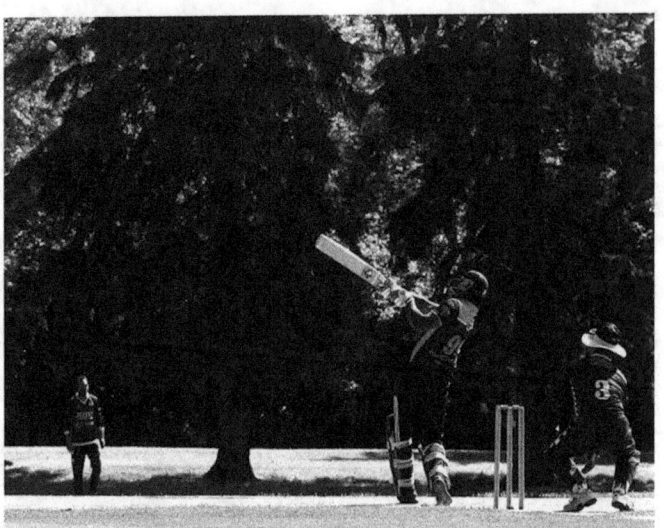

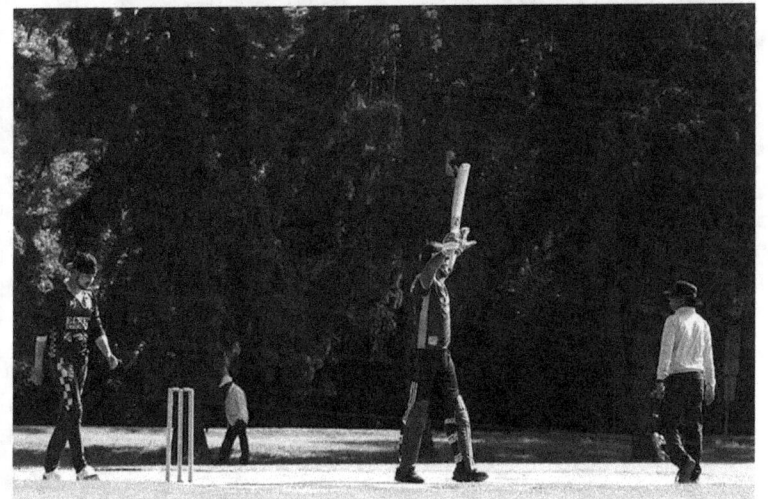

Big day out at the second most famous MCG

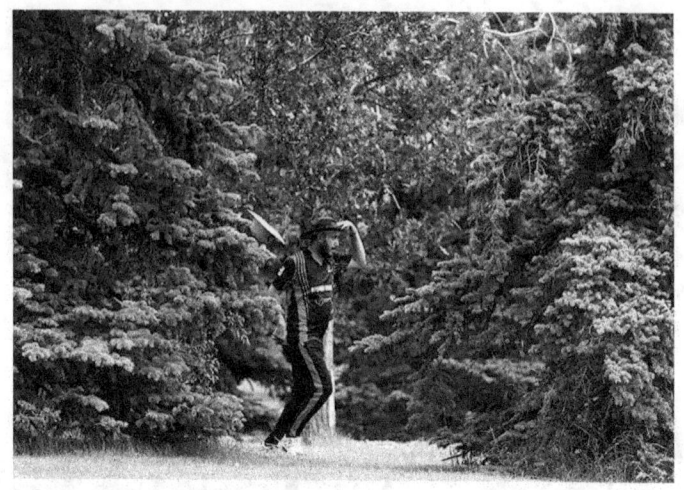

Rising Stars A 153/10 v 154/6 Gujarat A - Elite 50 over 17/07/2022, MCGii
Rising Stars' fielder almost lost his second hat…

Reach

Knock

Caught

Curse

Out

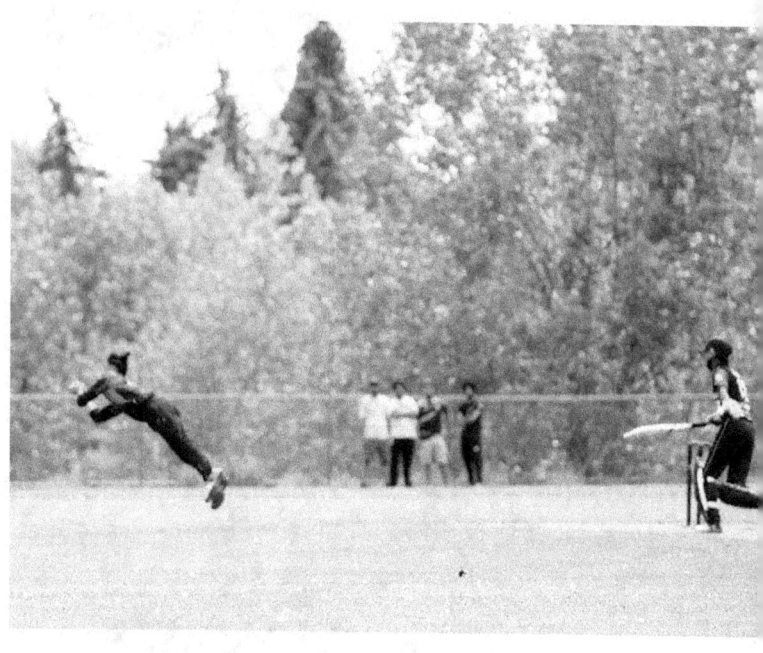

The Diving Catch

There is a famous story about the album art for London Calling, by the Clash. The photographer, Pennie Smith, was gonna bin this one iconic shot for being a touch out of focus. She was bitterly disappointed with herself. Then Joe Strummer saw a contact sheet on the tour bus and said, no that's perfect. Ends up being THE GOAT album cover shot. Unarguably better for being a little out of focus. Not so much in this case. The catcher here, Majid Iqbal, being in focus would have made this shot much better. As it is, it's enough for you, the reader, to see just how good a catch this was. Perhaps, if I'm to look at my photo with a more generous eye, it is my slow to focus reaction time which further demonstrates the startlingly quick reflexes of the Rising Stars' fast bowler. Top notch stuff.

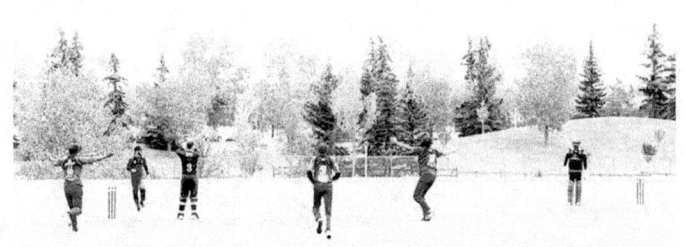

This is an excercise in pure self indulgence. This exposure was a mistake. Happens for a variety the reasons, maybe the sun burst out from behind clouds, maybe I just got set up and wasn't prepared. I never shoot with autofocus or auto-exposure so I never need to be angry with my camera when it doesn't do what I want. And when I don't do what I want, I end up with something like this which I'm certain no editor previously of mine would have passed to production but I'm the editor now meme.gif

(If this book sells a million copies I'm for sure hiring an editor for the next one. I need help.)

But a surreal image is fitting for an occasionally surreal game, capable of causing such surprise and upset amidst, what seemed to be (to me) on the surface, a sedate and orderly activity.

The other thing I did with this picture is use photo editing software to erase a distracting light standard. Normally I would abhor such behaviour as so much worse than sandpaper; however, I have learned in my adult life that all sorts of people have been at it ever since the very invention of the medium itself. So all I can really promise to you, the reader, is to announce when I've made an alteration but leave it to you to figure out where. My guess is, with the lousy print quality I can afford no one will know where the light pole originally stood. grinning face emoji.txt

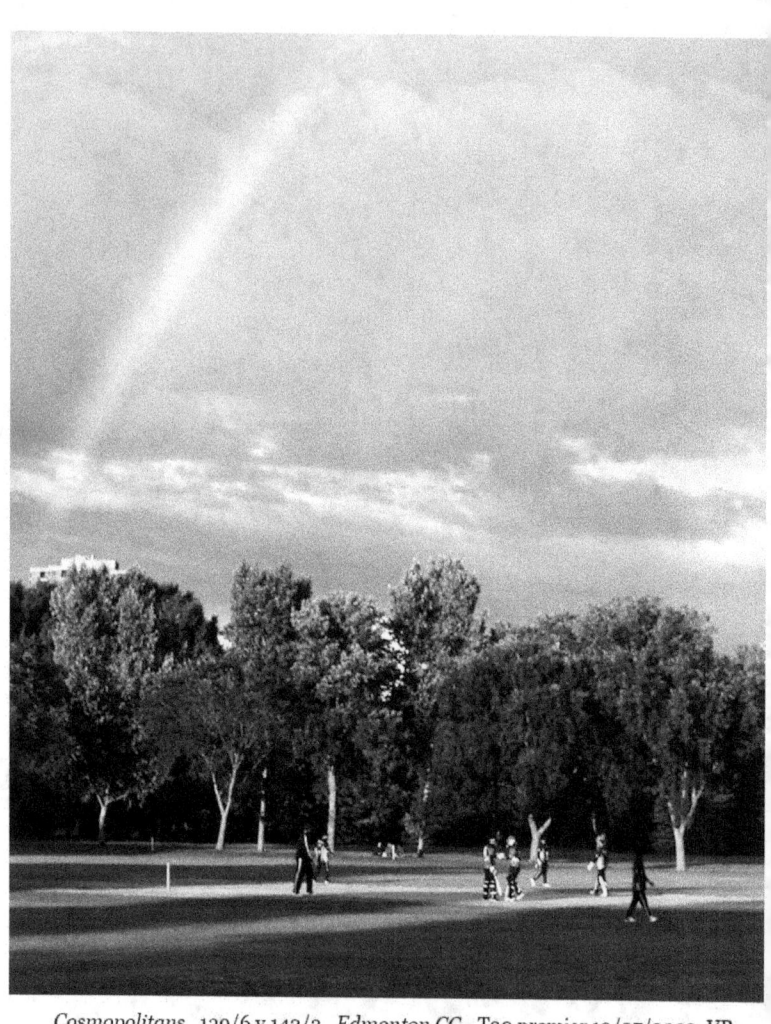

Cosmopolitans 139/6 v 142/2 *Edmonton CC* - T20 premier 19/07/2022, VP

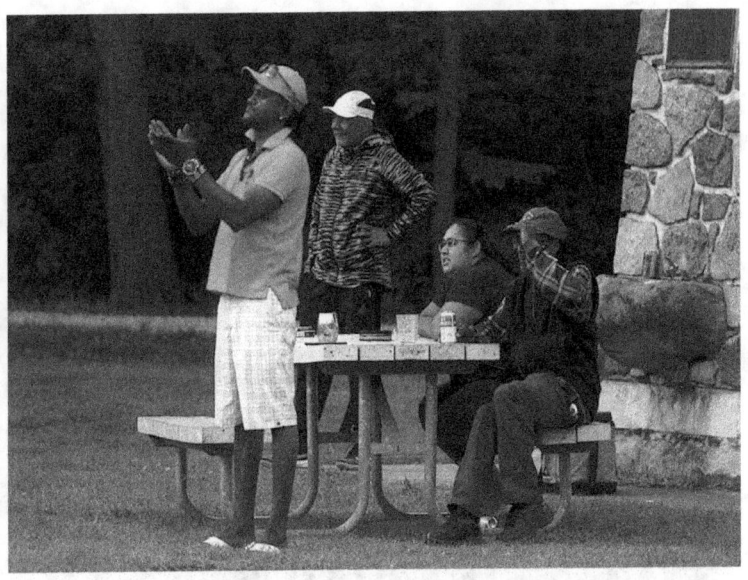

The season ticket holders. Like box seats at Rogers but cheaper (free), better food and drink cause you already brought the stuff you like, and better music. Best sports venue in Edmonton right here.

Edmonton Eagles A 188/9 v 154/7 *Scona B* - T20 1st div 26/07/2022, VP

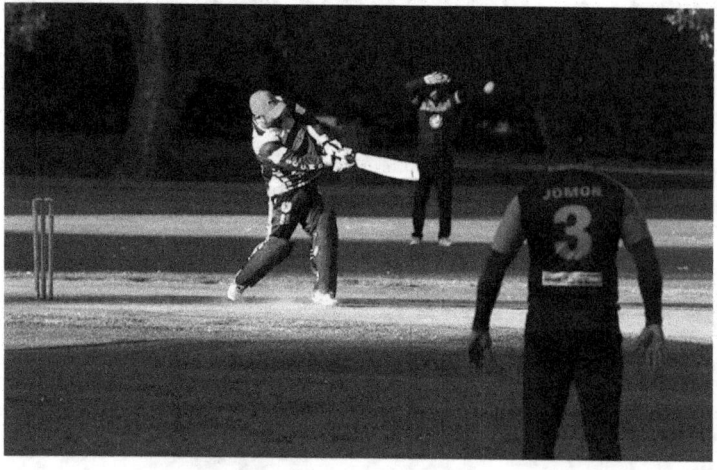

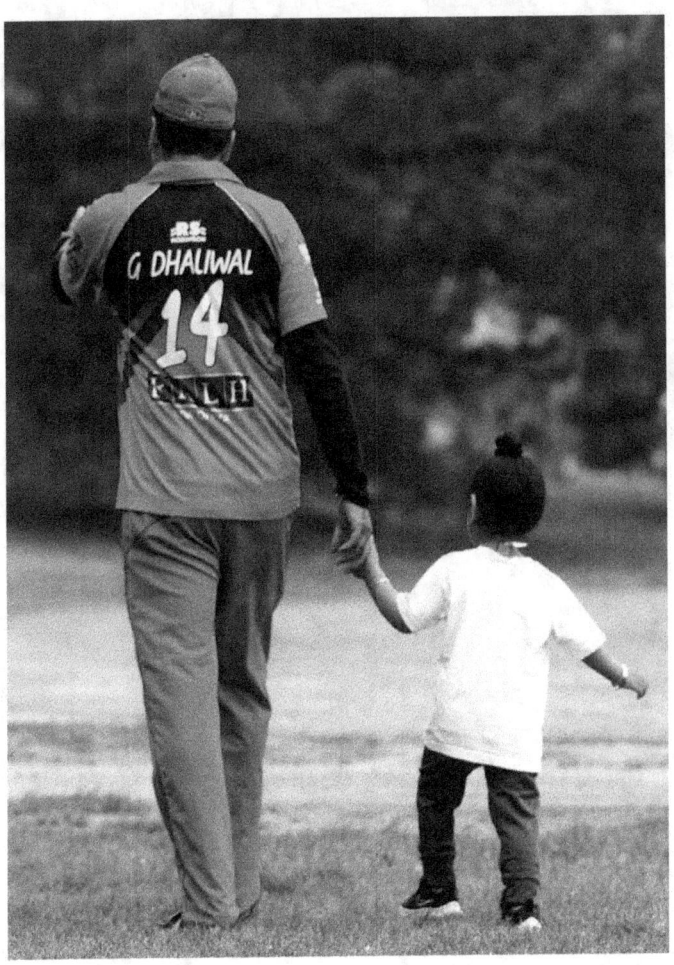

Millwoods Cricket Ground, 2022

Ginny Memorial A 230/10 v 229/10 *Elites A* - Elite 50 over 24/07/2022, MCG *(not that one, this one)*

Krish told me he didn't like the bus in the background of this one and I told him I agreed with him, but the bus drove through nonetheless.

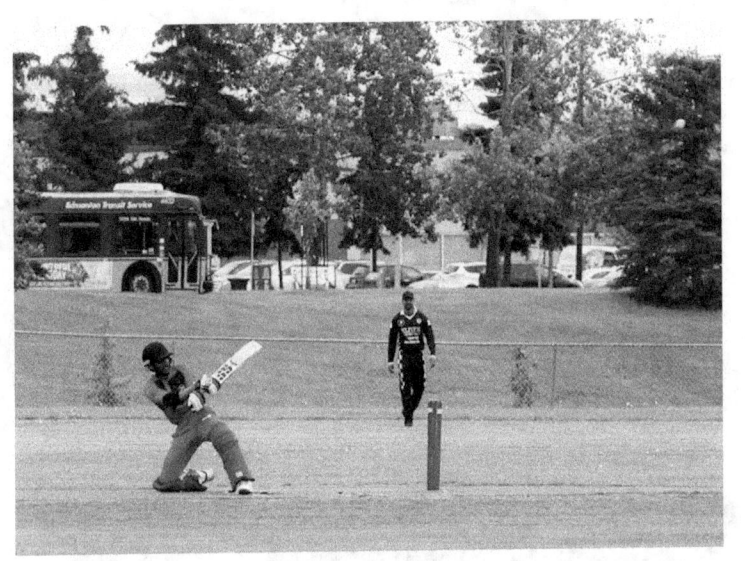

Skeptical spectators in Victoria Park, 2022

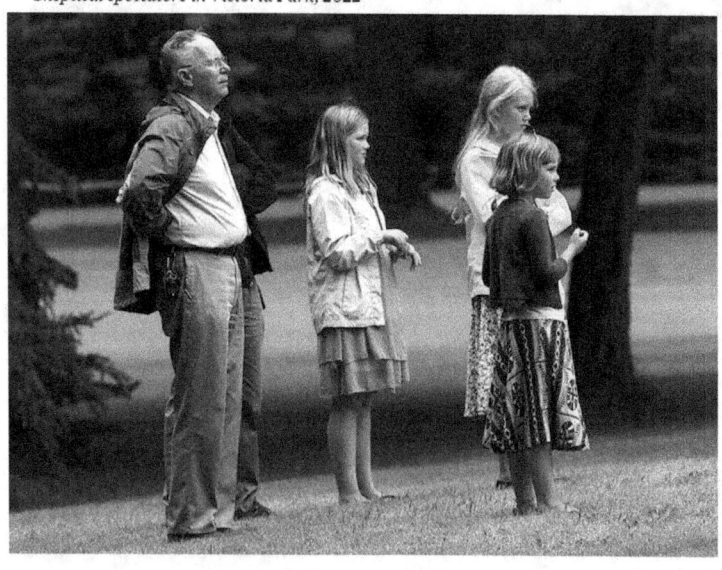

Ginny Memorial A 130/10 v 129/10 Gujarat A - Elite 50 overs 31/07/2022, VP
It started so well for Gujarat A, before the rain delay.

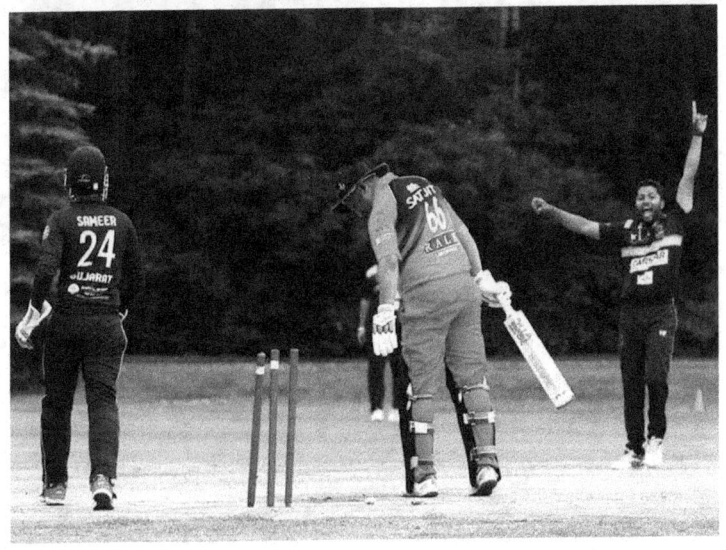

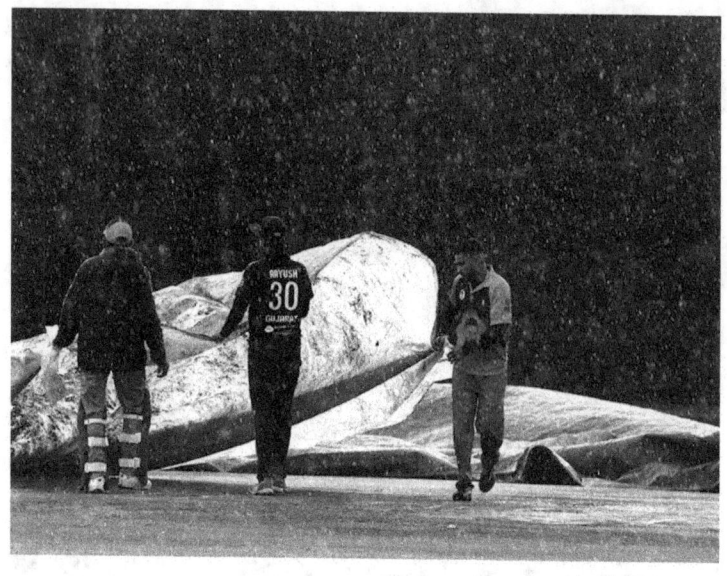
Rain covers come on at Victoria Park

Gujarat lads ready for a resumption in play after rain delay but

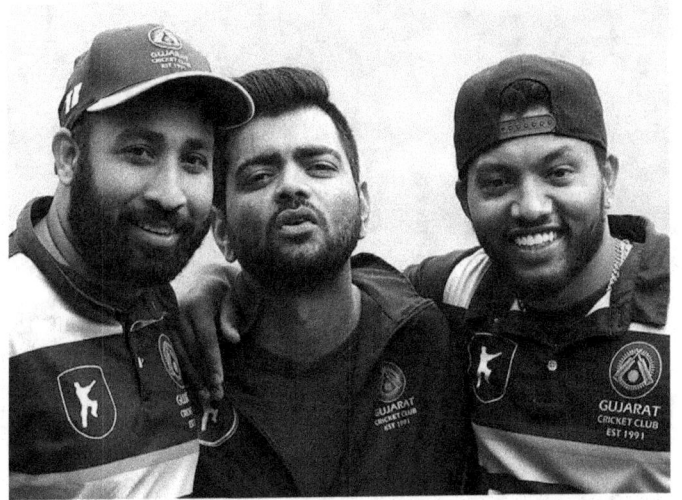

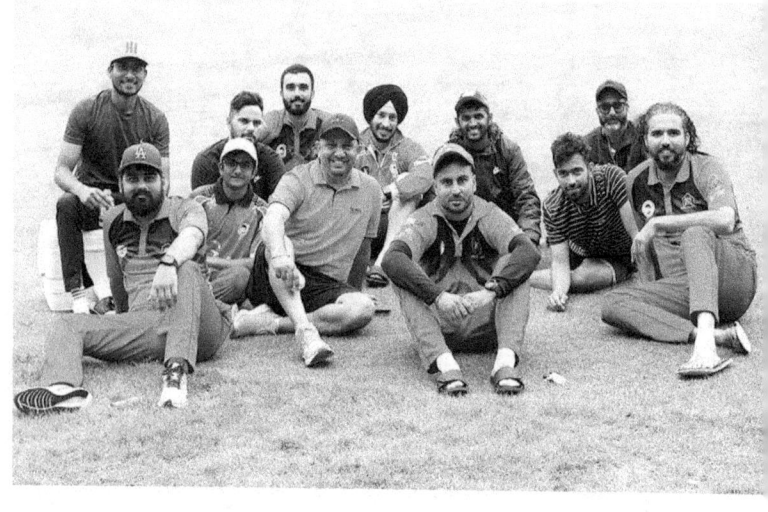

Ginny Memrial A prevail in yet another game with the thinnest of razor thin margins winning by a single run in the end. I gave Aditya man of the match because of one run he made in the field to save a boundary and the scoring run he made in the tail proved to be decicisve moments in the match.

Foreshadowing moments for the playoff finals yet to come.

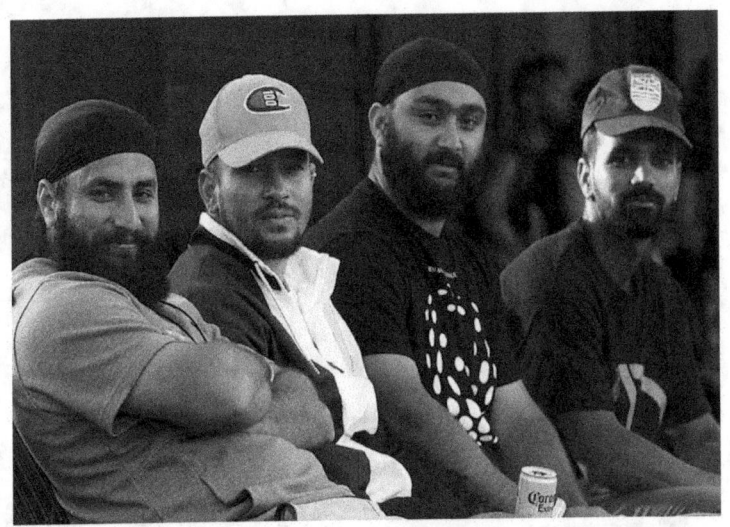

Famous faces in the stands at Victoria Park

Sangha Amrinder walking off after being caught at 39, named MOTM

Opposite page:
Ginny Memorial A 225/3 v 118/10 Edmonton Panthers A - Elite T20 2/08/2022, VP

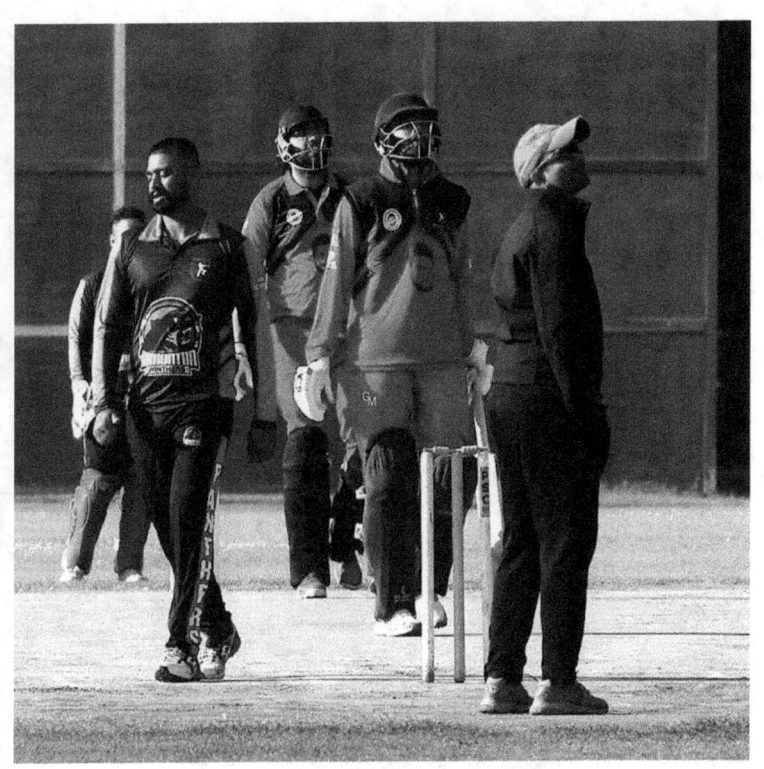

Opposite page:

Always on the lookout for a good moon shot. Nothing prurient, just the actual moon, a tricky thing to expose correctly.

Elites A 152/7 v 151/9 *Millwoods A* - Elite T20 04/08/2022, VP

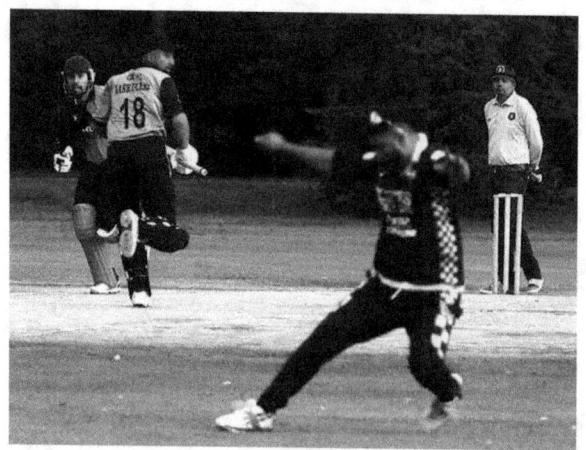

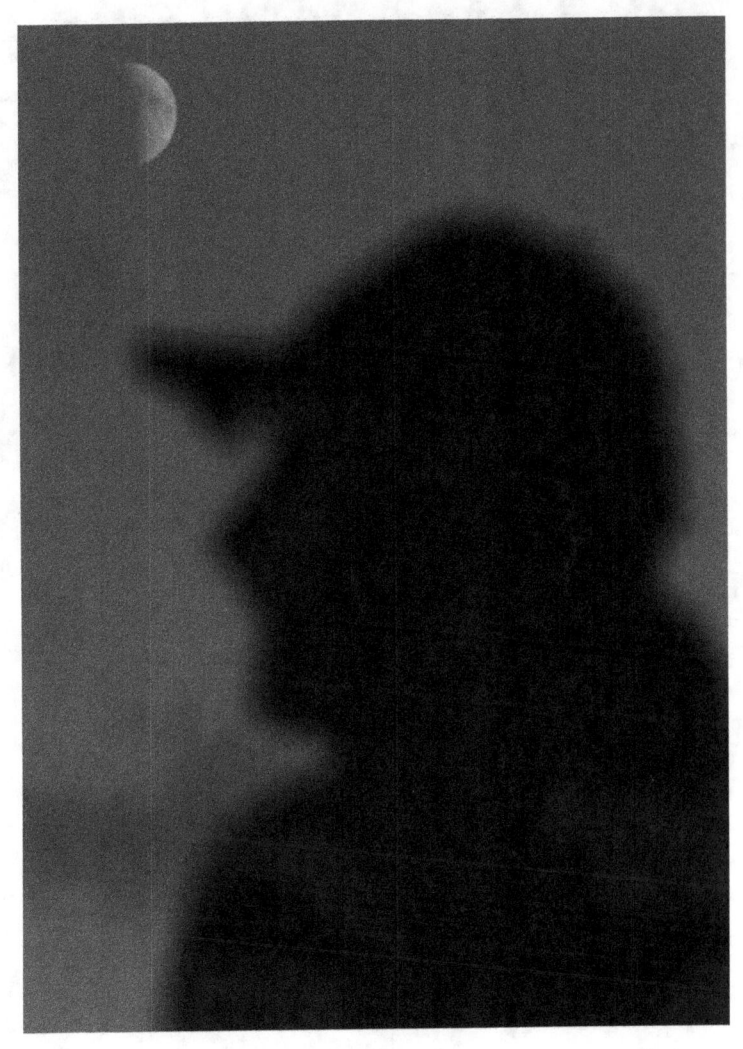

Opposite page:

World XI A 166/10 v 169/8 *Edmonton B*
2nd div 40 overs 21/08/2022, VP

Opposite page: Edmonton Lions A 207/3 v 156/7 Stallions - 1st div t20 24/08/2022, VP

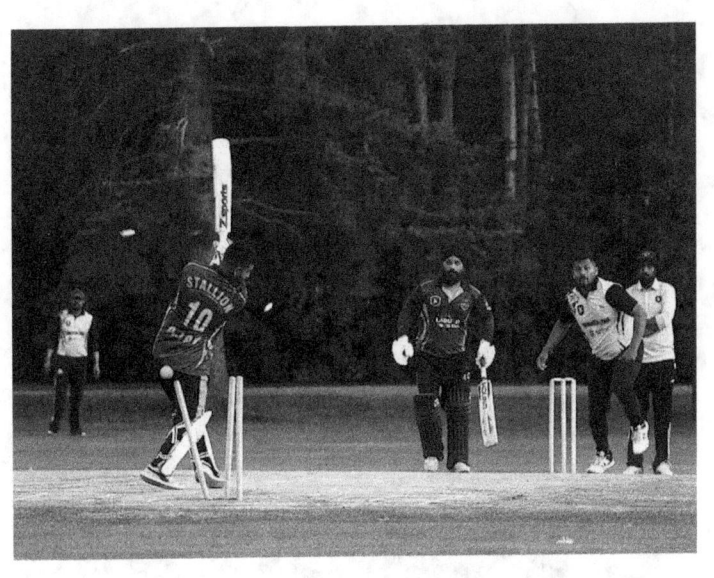

Cricket is super chill. It's not like a Peter Pan fairy that must be clapped at to stay alive. But also, if you sit too close to the boundary without paying attention there is a non zero chance of being bonked on the head.

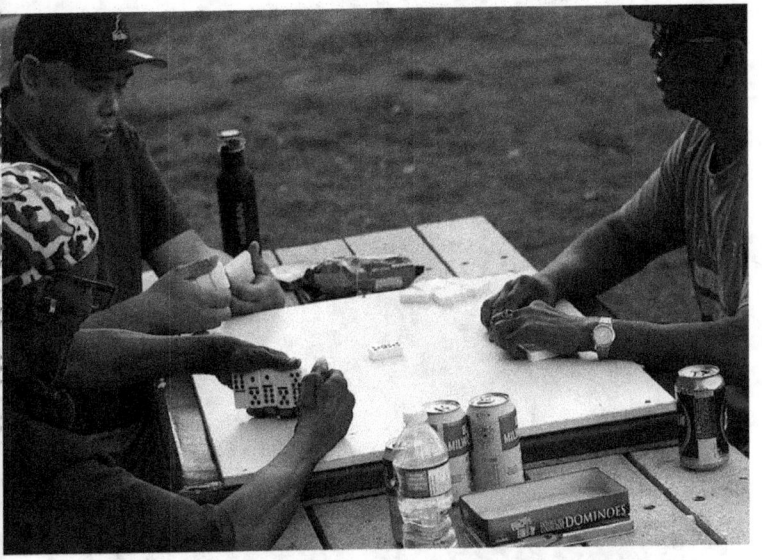

The domino players would never get bonked on the head. The domino players would catch the ball one-handed without looking and toss the ball back to the waiting fielder before resuming their game uninterrupted. This is true until I'm proved wrong.

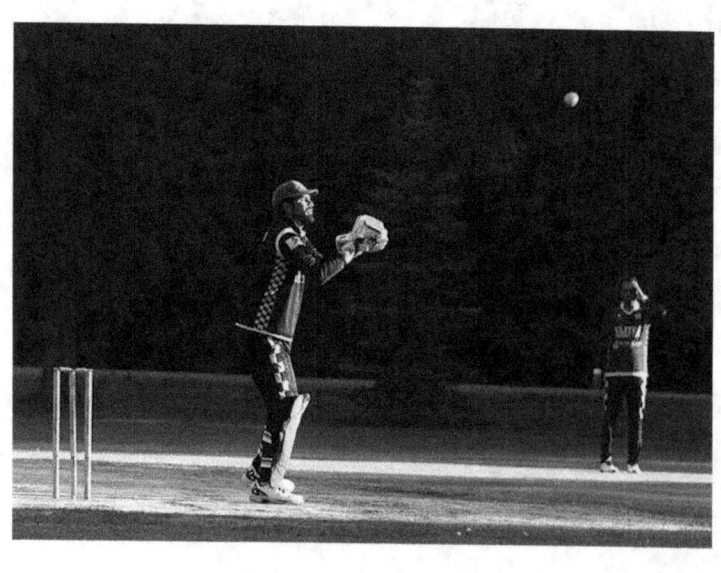

Opposite page:
Elites A 80/10 v 84/0 Shakti A
Elite T20 29/08/2022, VP

Following pages:

Greenfield 68/10 v 73/6 World XI A
1st div T20 31/08/2022, VP

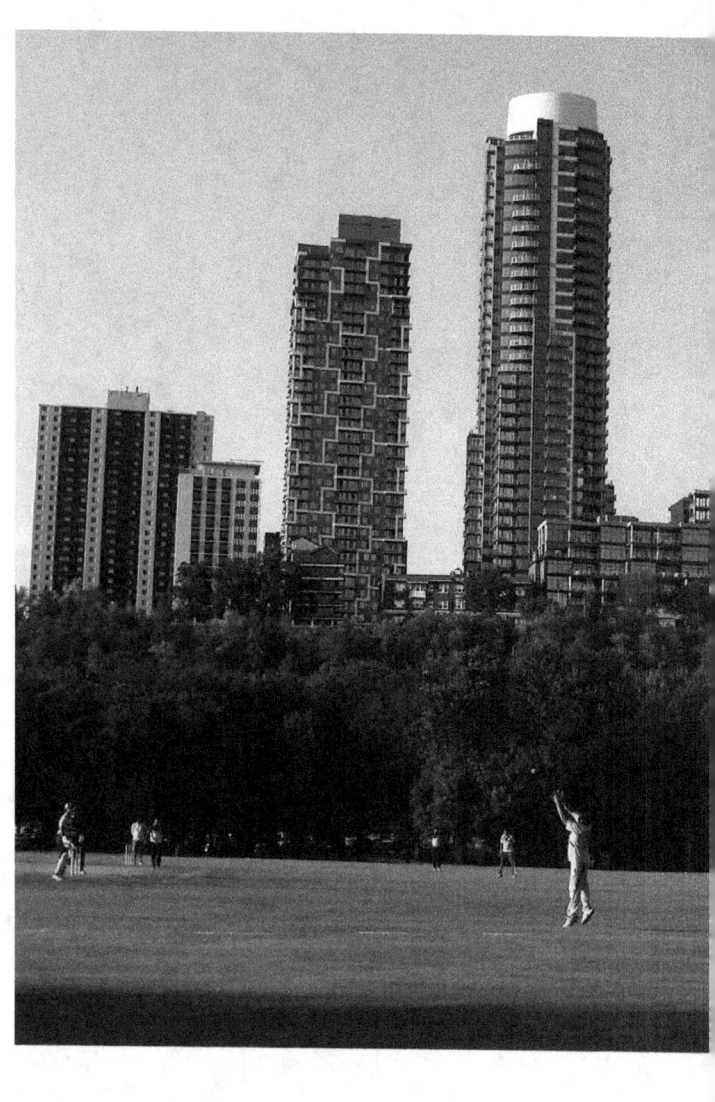

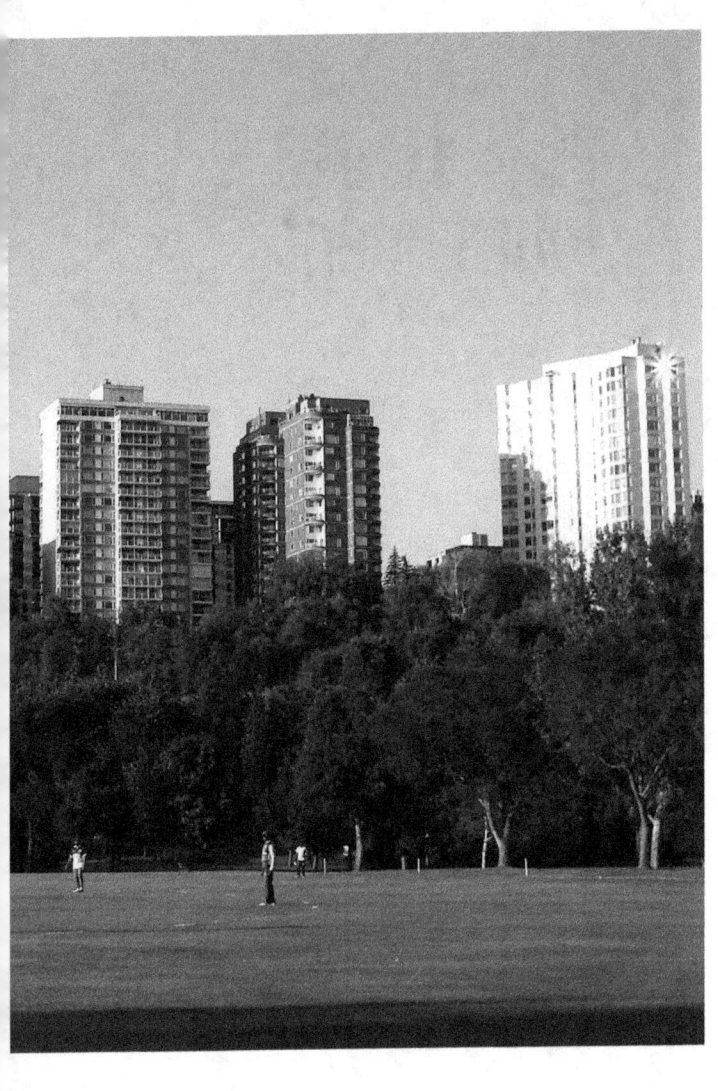

The 100K Tournament

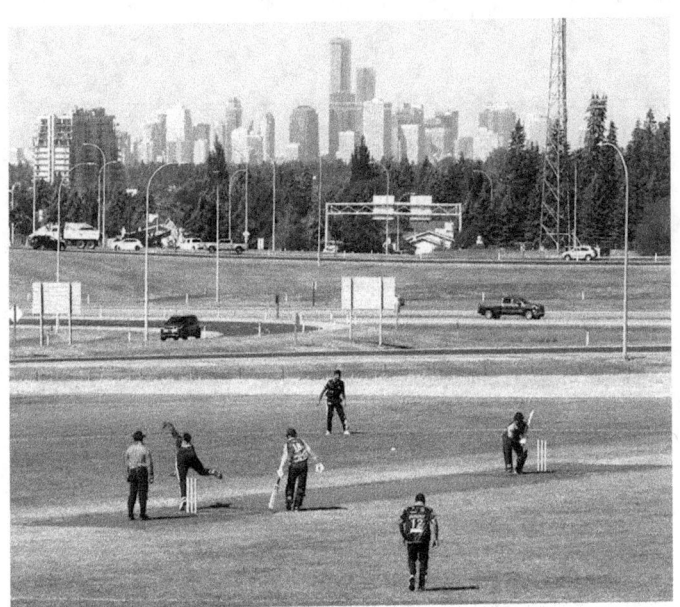

The Tournament

I love it when a thing lives up to expectations. Like how I've been planning this project for more than a dozen years and it was every bit as much fun as I'd thought it'd be. From the first week I showed up in the park with my rig, people were telling me about this big tournament in September.

A one hundred thousand dollar prize. I was absolutely flabbergasted. How much? For cricket? In Edmonton?!?

This is bound to attract a much higher standard of cricketer than I ever would have expected to see at this specific set of global coordinates. A team from Florida, full of Scottish internationals, as well as the captain of the Canadian national team.

Adrian Neill of the Florida Scorpions appears caught in a web of electrical wire and steel pylon while bowling vs Royal Punjab at Pusha Cricket Ground, 01/09/2022

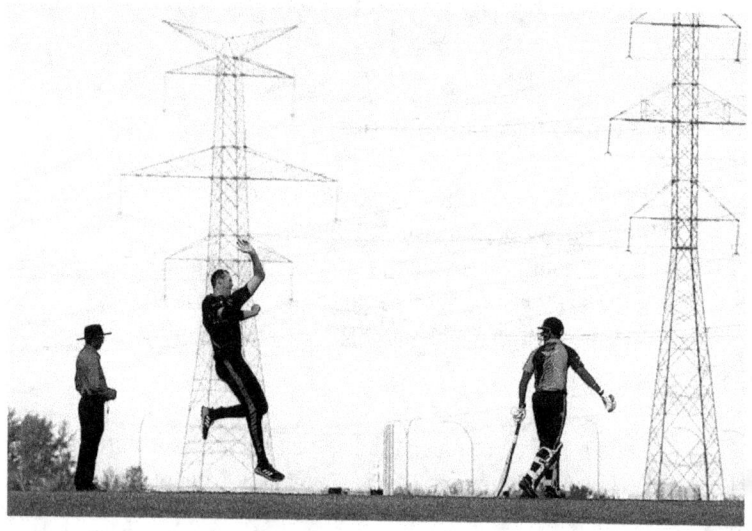

Edmonton United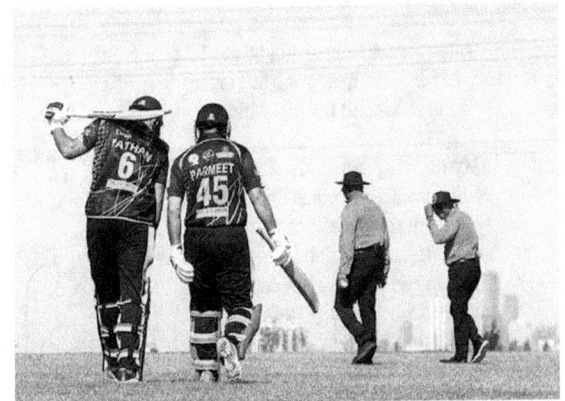

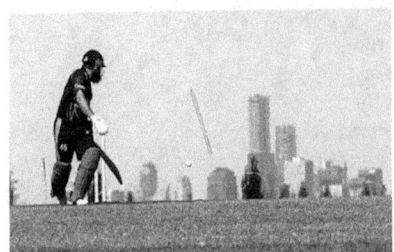 vs

Challengers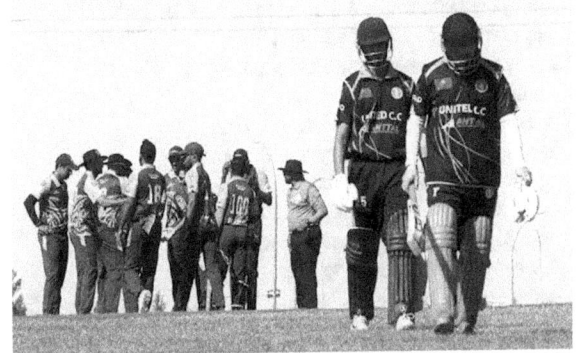

Other teams from around Canada traveled in with heavyweight ringers from Pakistan and the West Indies.

My first trip out to the Pusha ground resulted in some delightful shots from the edge of the city, the downtown skyline visible prominently in the background. It was so windy that day the umps were forced to remove the bails from the stumps because they wouldn't sit still on their wee little perch.

The semi final match at Victoria Park on Monday morning between Greenfield, from Edmonton, and the Florida Scorpions is a top 5 all time live sport experience.

The only thing worse than watching an Edmonton team lose to a Calgary team in a final is watching a Calgary team win and Edmonton not even being there at all. So by every measure except an Edmonton final victory this was a perfect tournament. (By every sporting metric, I'm still annoyed by the lack of paper towel in the clubhouse washrooms. The tournament prize was $100,000, surely someone could have found enough cash to clean the toilet facilities.)

Previous page:
Majha 11 v Surrey Hawks
morning 2/9/22, VP

Opposite page:
Maple v Hawks 11
afternoon 2/9/22, VP

Opposite page:
Greenfield v Surrey Hawks - Evening 2/9/22, VP

This demanding little guy wouldn't stop chattering at me until I turned around and snapped his picture. Good one tho, super cute.

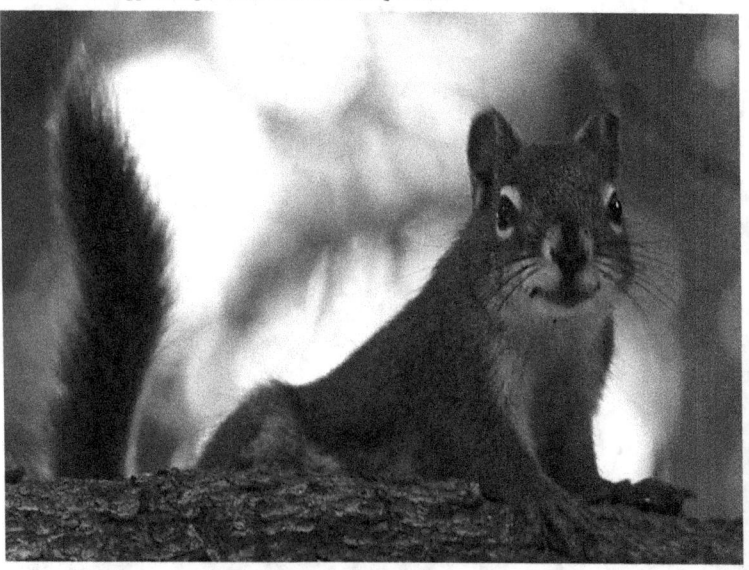

Flying birds are more difficult to shoot than chattering squirrel posers.

Florida Scorpions v Newton Surrey Lions Millwoods 3/9/22
(Scorpions, according to pitchside gossip, are hungover and grumpy.)

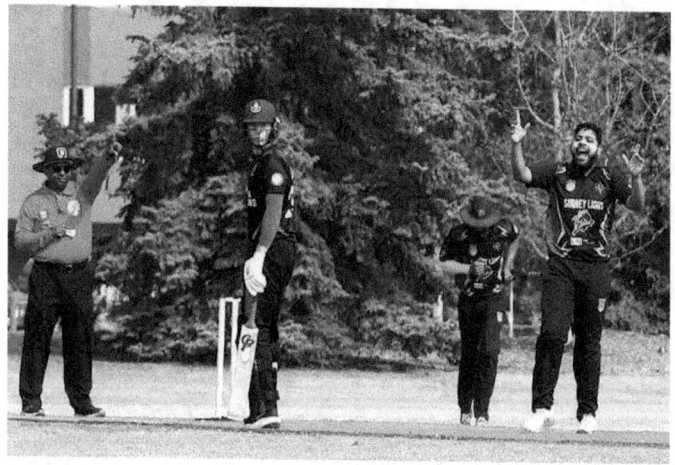

The Minor Controversy

One of my favourite big historical myths (which MAY be hugely exaggerated or even invented whole cloth by the knife sales guy who told me this) is when 19th century Japan, in a bid to become a modern global nation, outlawed the manufacturing of all swords and so blacksmiths were compelled to switch to making kitchen knives instead. I suppose, given the military and political direction the country would take in the immediately subsequent decades, the suggestion might be that the symbolism was lost along the way. Nevertheless, I'm a fan of the idea. Knives and swords are cool, obviously. But knives are WAY more practical for chopping fish heads and onions and maybe it's a good idea to make it illegal for people to own or possess a thing whose only purpose is for killing humans.

The point is, all the dedication and discipline and craftsmanship going into those legendary Japanese swords can go into the knife instead, so an orthodontist or a chartered accountant can spend $1700 on a knife for chopping carrots and maybe, for a little bit, feel the visceral thrill of pretending to be an old-timey legendary samurai.

Buddy, what does this have to do with cricket?

Cricket, and by extension all sport (even the weird American games like the one they call football even though there is only one guy who actually kicks the ball which also isn't a ball but even that game), are like knives compared to the military sword. All the same kind of discipline and dedication goes into both right?

Here's the thing of course, if that orthodontist or chartered accountant spent $1700 or $17,000 or $17 million on a finely crafted and ritually honed razor sharp sword all he can do is hang it on the wall. If he actually used it he'd be a psycho and they'd put him away. But if he spends $1700 on a knife to use every day, and can actually feel as if he is contributing meaningfully to his own life, in the way preparing one's own food often does, then maybe it's worth it.

Now, don't get me wrong. I'm not the MOST naive person you've ever met. I have seen RRR (Rise, Roar, Revolt) on Netflix. When the Brits come to your village in the middle of the night, knives and not even swords are enough. Guns might well be necessary. But eventually, I believe this sincerely, all the imperialists will be dead. People will then need to devote themselves to a martial art less dependent on explosive projectiles.

Cricket fulfills this role admirably. It's fierce and dangerous but always aims, at the end of the game, for a one hundred percent survival rate.

This is, for me, a beautiful thing.

Safe?

or

Out?

But it doesn't equally mean a permanently blissful haven, free of conflict or strife. There is all manner of opportunity for a really chewy bit of gristle filled beef. Unresolvable talking points for guys like myself who sometimes just wants a serious argument.

Was this guy in or out? I honestly thought my camera had solved it. When I'm actually in the process of taking photos though, I can't really see what's happening. Whenever I press the button the mirror flips up and the shutter opens to make the exposure but the screen through the viewfinder goes black. So when I see something ABOUT to happen I start pressing the button as fast as I can (the motor drive on my rig doesn't work so well with the ancient dusty processor inside the digital camera guts). And even though in this instance each exposure is only 1/1000 of a second there is still an inevitable gap between frames that separates it from the high speed and high definition cameras you see on the international broadcasts. That means when I heard the fans arguing with the square leg ump about giving the batter the benefit of the doubt and I ran over with my camera to show them the screen I thought for certain I would settle the argument. Lol.

In the end I'd been so easily talked round to the opposite conclusion I no longer knew my arse from my elbow.

This is the good stuff that keeps sports knife-sharp. It's not a sword but it can still cut, if you're not careful.

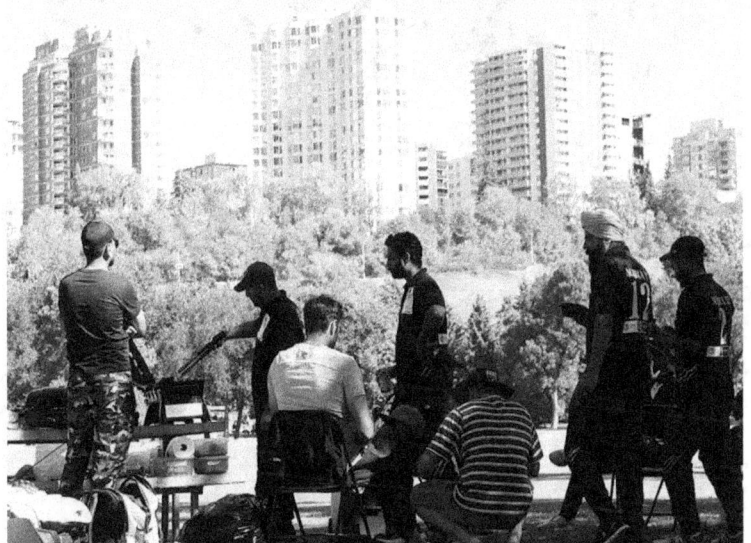

Well prepared for a long day in the field.

Two hats! Took a long time for me to figure out why I'd always see cricketers wearing two hats. And quite honestly, I never did in fact "figure it out."

I just asked someone pitchside and they were like, "they're holding the hat for the bowler so he doesn't lose it in his run-up."

Talk about stating the obvious, to everyone but me.

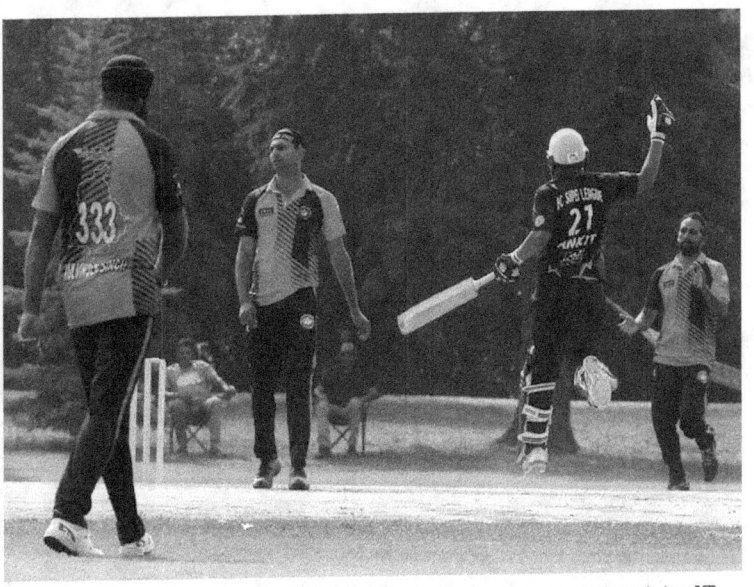

Royal Punjab v Newton Surrey Lions - morning 4/9/22, VP

Look at these fine, brave fellows on the opposite page, so nonchalantly trusting the skills of the recreational golfers on the fairway behind them.

Eventually they grew bored and invaded the golf course for some impromptu cricket, lol.

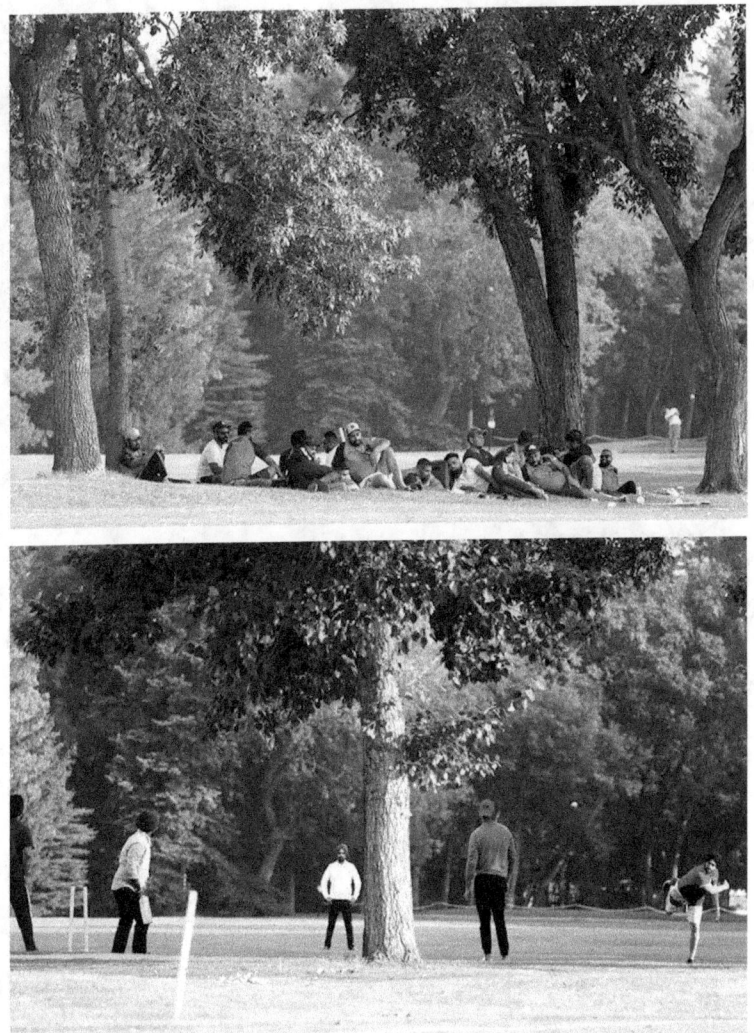

Opposite page:
Florida Scorpions v Saskatchewan Strikers - afternoon 4/9/22, VP

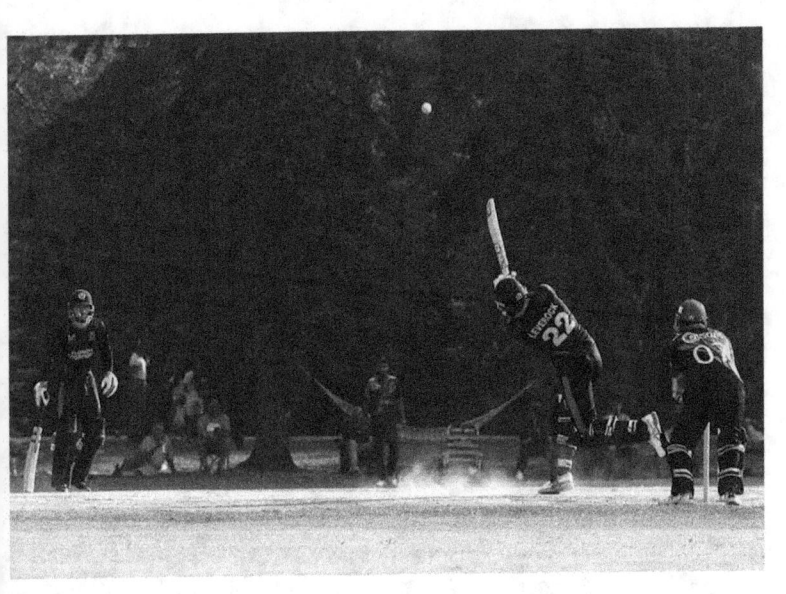

Whatever I can do to encourage more women to come out for the cricket.

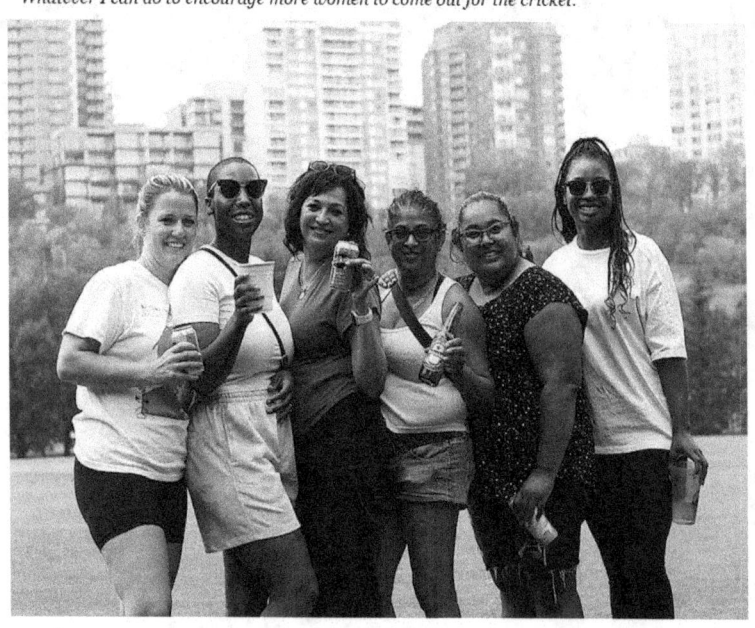

The Devil's Wicket

I've never played cricket. What goes on in the middle of the pitch is a mysterious blur of activity obscured by the fog of ignorant eyes. I just push my little button and see what comes out the other end.

The Scorpions did not like this wicket. They complained about it in conversation with some fans on the boundary. I had been living under the illusion previously that the VP wicket was a huge source of pride. Like, "what a good wicket we have!"' kind of thing. But here I am discovering instead, from some full time pros no less, the wicket is deplorable. Very funny and confusing stuff, your intrepid correspondent is learning.

From my perspective the VP wicket rules. As photogenic as any other world wonder. Catches the light just right, kicks-up little dancing dust-devils. Lively for my lens.

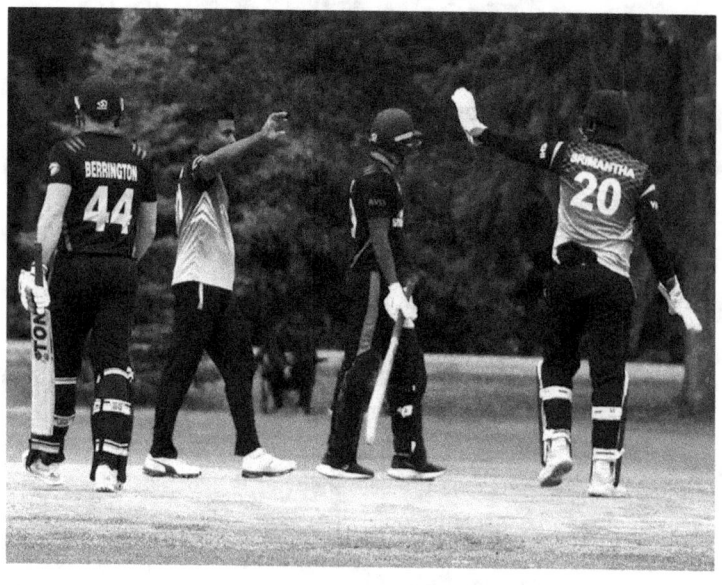

It's no wonder the Scorpions lads preferred the wicket out at Pusha. They knocked the ball into nearby farmer fields all morning.

But here the wicket and the weather conspired together to leave the Scorpions undone.

Best exemplified by this little sequence of your man tripping over the flying wicket stick after Greenfield's massively enthusiastic stumping.

Truly a mighty moment in the history of Edmonton sports.

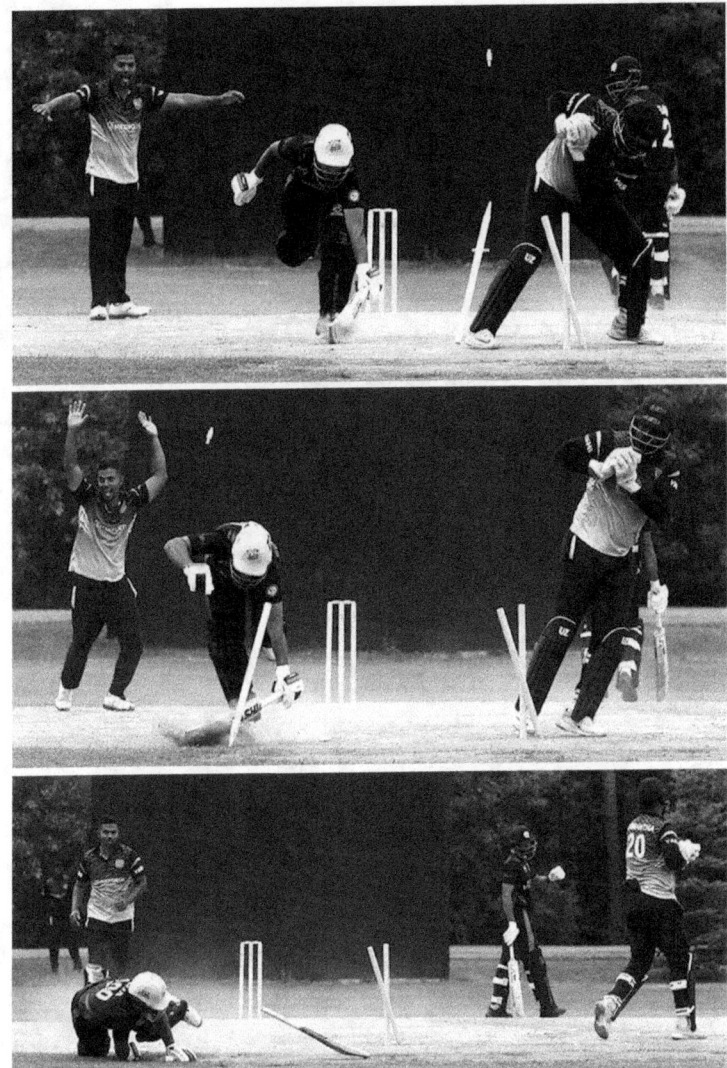

Opposite page:

Handshakes all around but you know the Scorpions lads are disappointed going home early and empty handed.

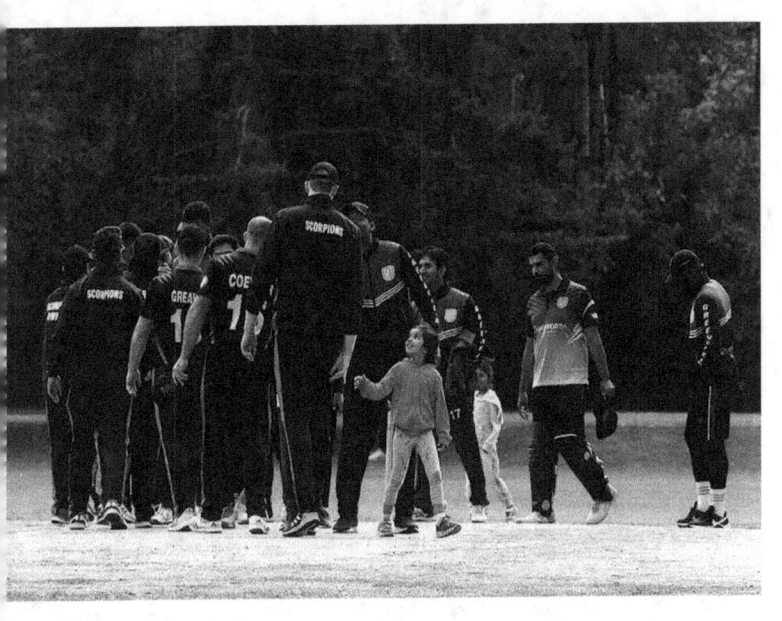

This page and opposite page:

The cute, the weird, and the grumpy

*The Final.
76ers v Greenfield for all the marbles.*

You can find the game for streaming on YouTube if you search Edmonton Champions Cricket Open 2022.

Helluva match even if the Edmonton team lost. :(

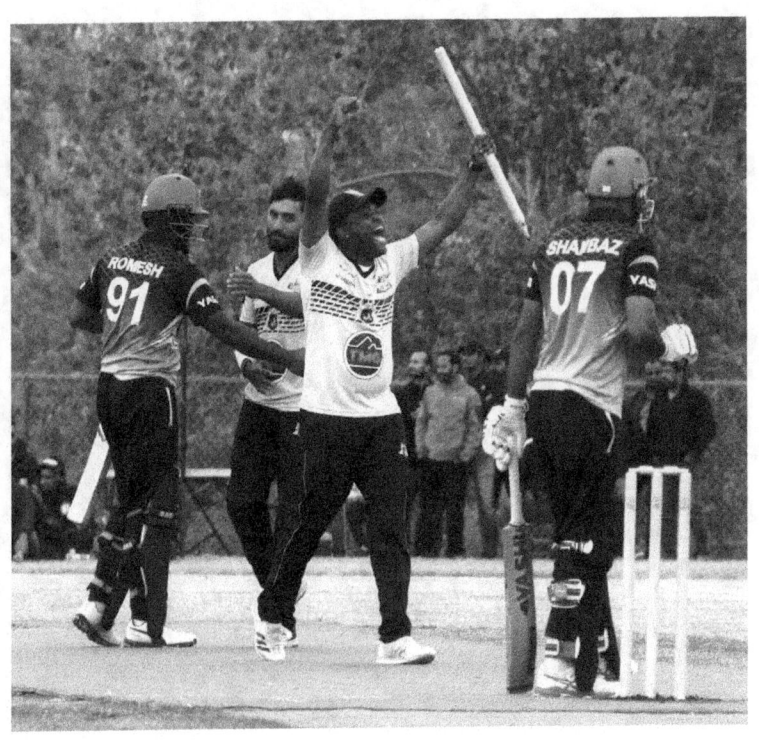

Legend of Edmonton cricket, Iroy Mark holds court on the occasion of his birthday.

September 2022, in Victoria Park

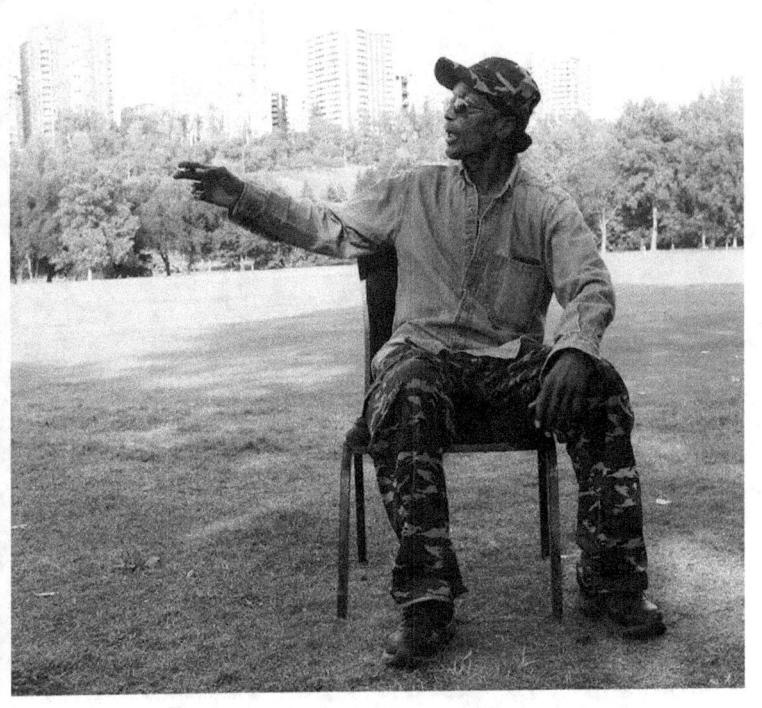

Challengers B

vs Edmonton Lions A

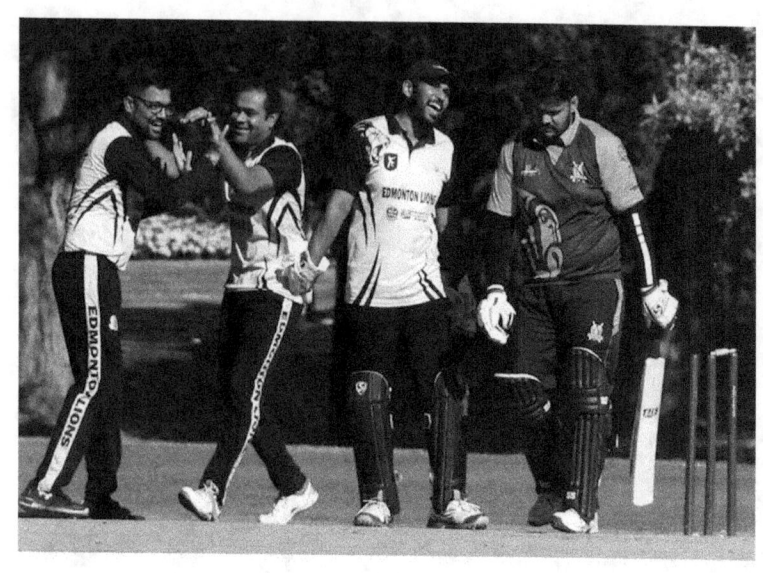

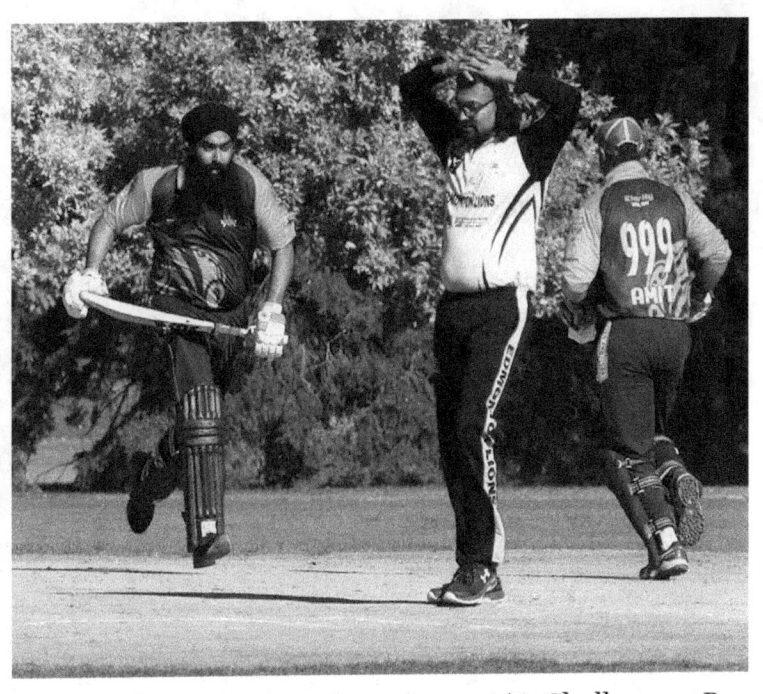

Edmonton Lions A 124/7 v 126/6 *Challengers B*
Premier 40 overs 02/10/2022, VP

The EDCL 50 over Elite Division Final 2022

The game for all the sausages.

After all the excitement of the big tournament I'd almost forgotten about the business end of the league. The playoffs. The trophy. That thing everyone worked so hard to hold on to from the beginning of the season. Like everyone knows, it's not the object that's exciting, it's everything the team experienced all season which allowed them to hold the trophy aloft which actually matters.

Knowing who won the final, and the circumstances of the match, it's fun to go back and look at some of the real squeakers Ginny Memorial pulled off all season. Those one run victories, occurring under overwhelming odds. Overwhelming? I'm not a bookie, a mathematician, or an experienced cricketer so you'll need to take my assessment as read. Insurmountable, impossible seeming odds. Each time I felt CERTAIN that GM could not win, they did.

Ginny Memorial with the trophy, 10/10/2022, Victoria Park

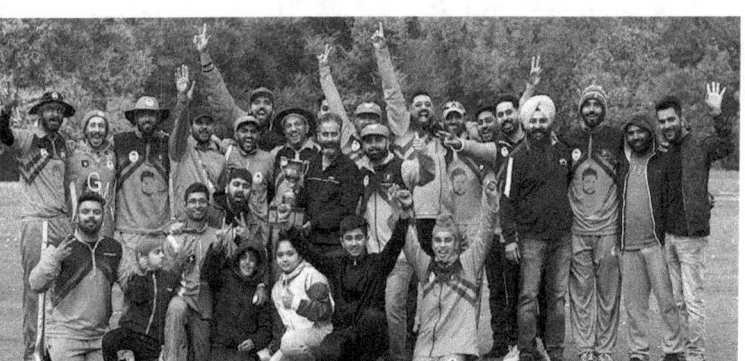

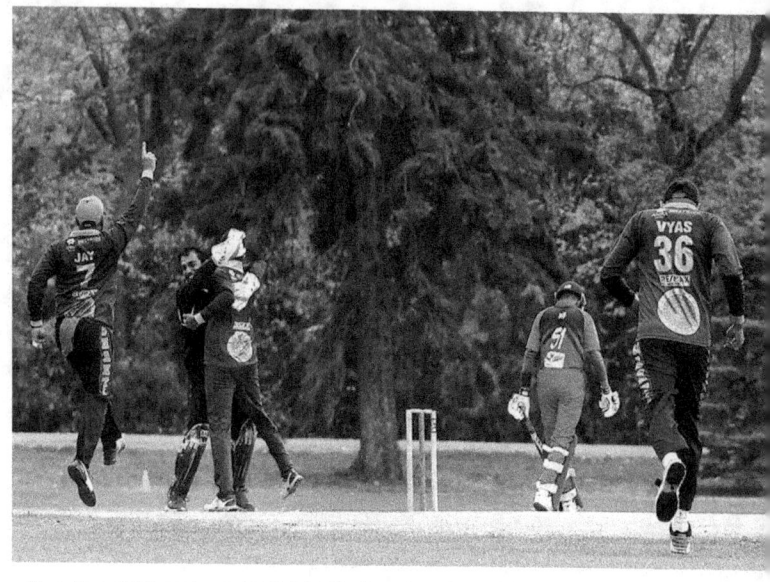

Ginny Memorial A 139/10 v 71/6 Shakti A (Duckworth Lewis - GM 37.4/47 ov - S 25.5/47 ov)

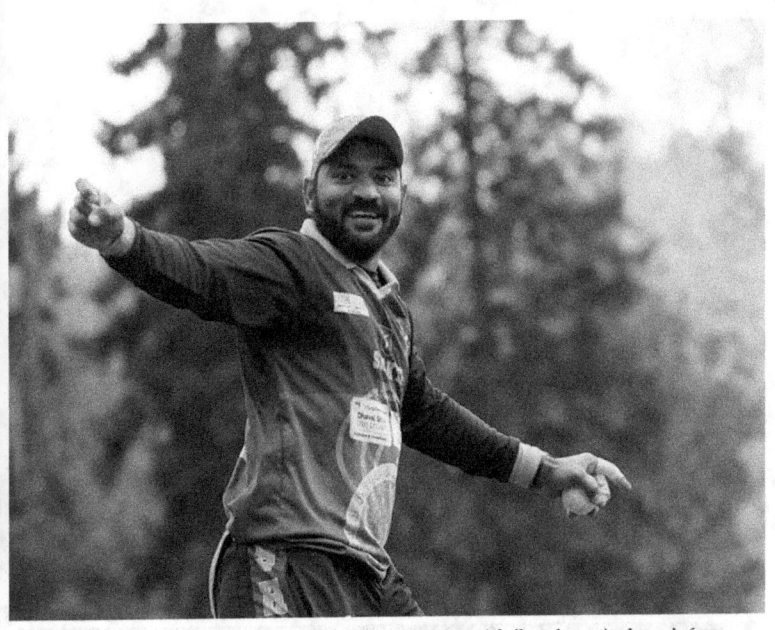

Shakti flying out of the gates, bowling Ginny Memorial all out for a miserly total of 139

Ginny Memorial by contrast had a terrible start. You'd think this catch is nailed on caught.

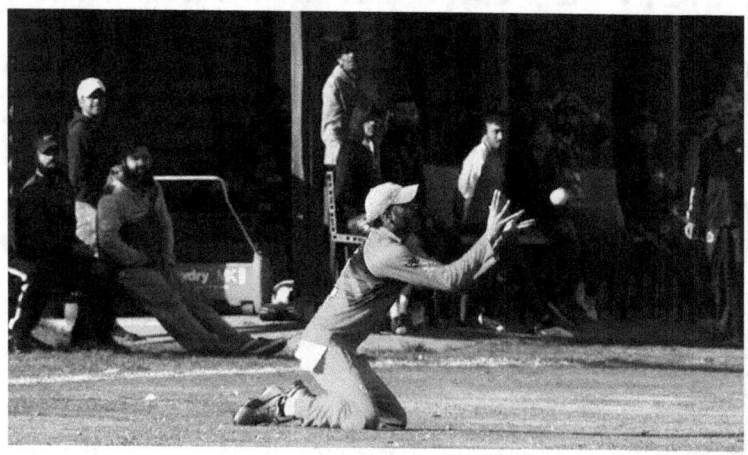

Fortunes rise and fall on twists of fate. Gary Player, a once famous golfer, had a line about luck but I don't remember it. This match winning performance felt like more than mere luck though. I've seen this before. Ginny Memorial do just enough, capturing the wickets they need before the fates intervene.

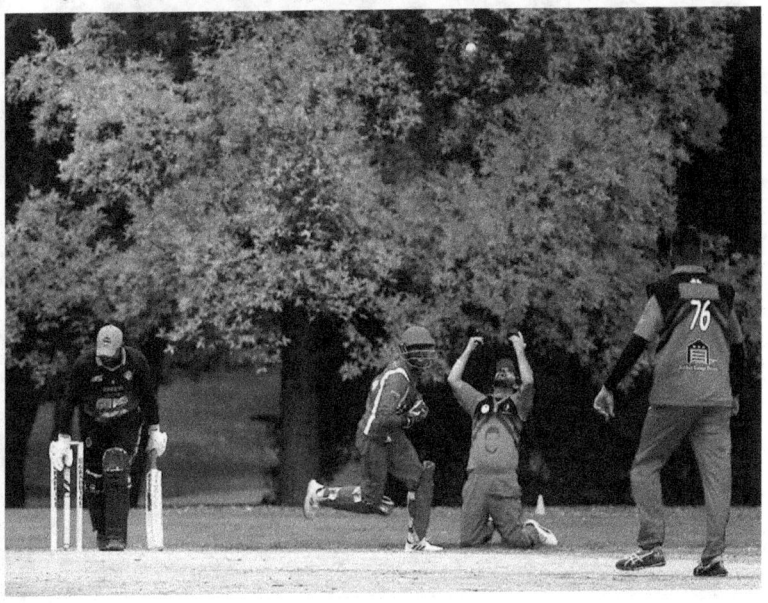

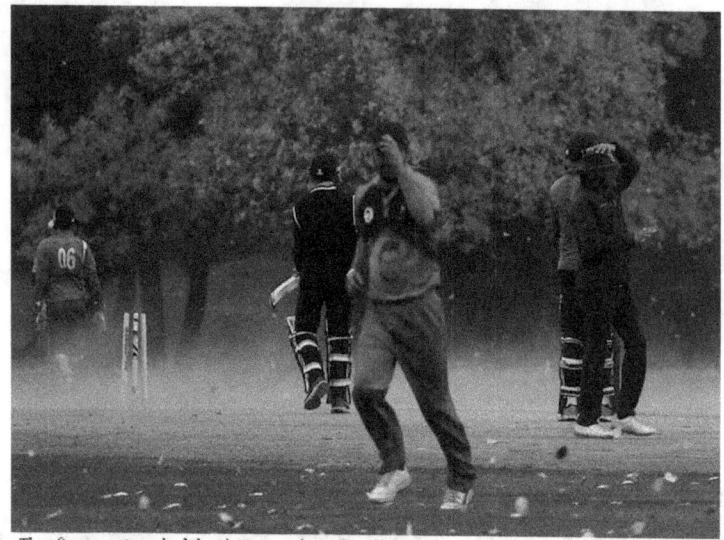

The afternoon storm had the picturesque intensity of intervening deities from the dramatic realms. And who could blame those capricious gods? It must be considered the heights of hubris to goad the gods in such a way, outdoor sports in Edmonton on a Thanksgiving Monday. What good fortune to see as much play as we did. Bad luck for Shakti though who ran out of time and wickets.

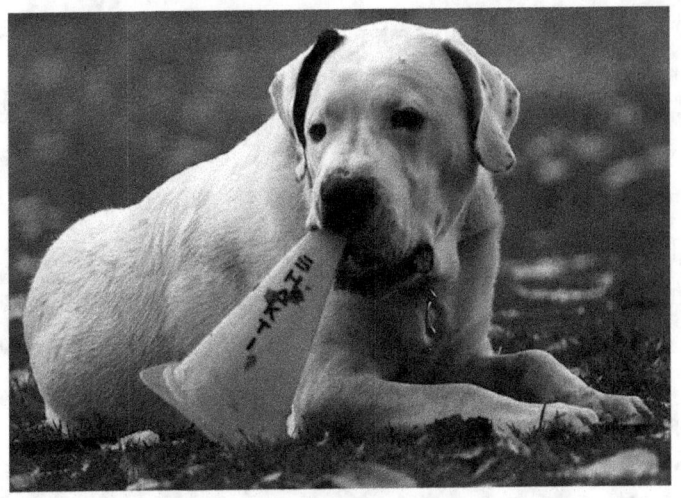

After a long break in play, somewhat anticlimactically, the ump pulled the stumps to award Ginny victory.

I think I've written several times how I feel about my own sense of certainty, (maximum level untrustworthy) but it does create a not unpleasant feeling of surprise whenever my predictions are defied.

The way Ginny Memorial won the final, on a Thanksgiving Holiday Monday is mysterious to me only because it might take me years yet to grasp the delicate intricacies of Duckworth Lewis. It might as well be as complicated as the theory of relativity for all my capacity to understand or explain it but somewhere in that morass of mind numbing confusion there is a core belief that someone understands what's going on. In spheres of human activity other than cricket this could easily be seen as so willfully naive it's deliberately blinkered.

But cricket doesn't require my understanding. Cricket is beautifully unselfish in rewarding my ignorance with delight and enjoyment.

It was, and I must insist no credit be given to the UCP for this phraseology, but it was, in fact, my best summer ever.

Congratulations to the 50 over Elite division champions Ginny Memorial and thank you to every player, manager, fan, and ump for keeping cricket alive in Edmonton.

I love you all.

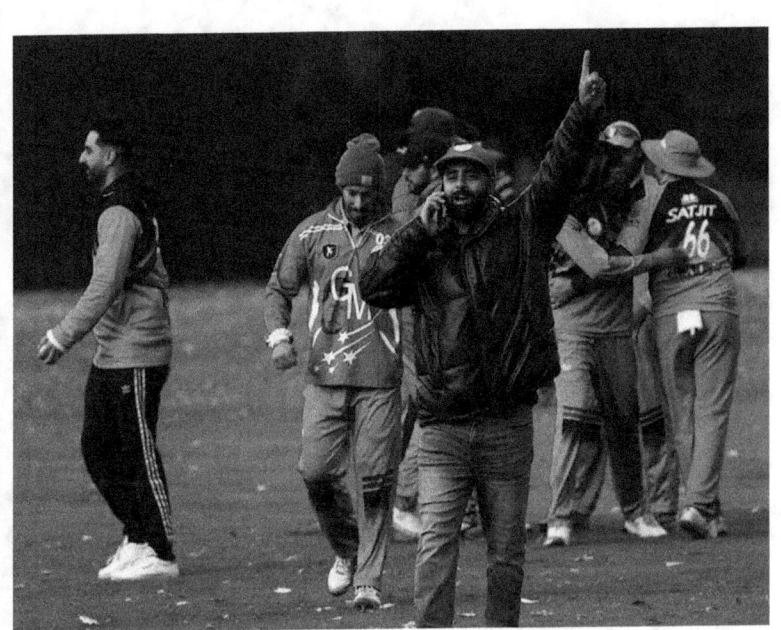

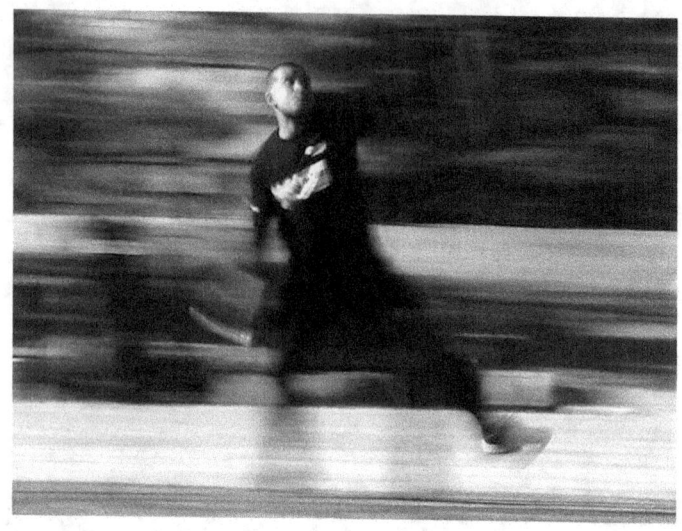

Umps XI v Executives XI

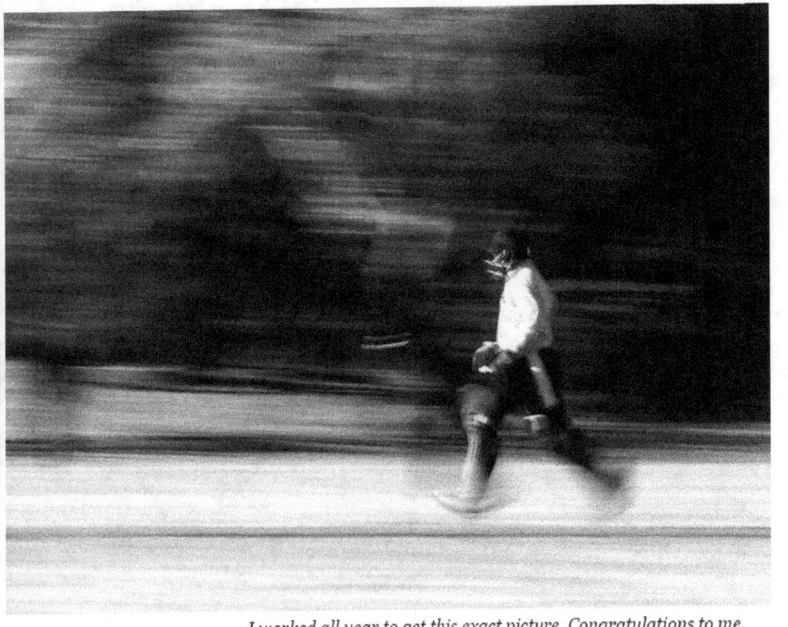

I worked all year to get this exact picture. Congratulations to me.

JANITORIAL DUTIES

The Golf Idiots

I write this as a guy who for the first time in his life would call himself a golfer. I have always previously in my life disdained golf, living by Mark Twain's maxim, "Golf is a good walk spoiled." But as it happens, I walk most everywhere anyways and having a few clubs and a ball to chase does not in fact spoil my walk. Of course, I rarely actually do "a full golf" like, on a course, with a scorecard and the beer cart and the green fees, etc. I go to the range with my free clubs from a community hall junk swap. I buy a bucket of balls and whack them for a while, then I go over to the free little putting green and practice chipping and tapping (putting). Then I can do golf once or twice a week for like $10 a week and that way I can afford golf.

It's fun. I understand the appeal. When you really hit the ball just right and it goes long and straight ahead it's pretty satisfying. So I don't think these guys are idiots just for playing golf, like I once might have done. No I hate these guys for trying to play their golf off the cricket pitch. Why are they doing this? It's not the Masters. They don't have a dozen television cameras focused on their every move. They can just pick up the ball and go back to their side and drop the ball and play from there. It's totally allowed. The two chumps who are fully on the field and way too close to being completely in front of me to be comfortable with them playing there, even if it wasn't a cricket pitch, considering the errant landing of the shot they've just recently played. When I first said, "Hey you can't play from there!" and they replied, "Yes, we can," I became more visibly agitated. "I'm about to hit you with your own feckin clubs if you don't get off the goddam pitch." *

*(This is almost certainly revisionist history,
there is no way I really said something like this out loud.)

I don't remember what I actually said but I must have used some kind of vulgarity because buddy got all huffy with me and said, "There's no need to swear," but then they shuffled away.

I sat back down in my chair in a state of discomfiture. I don't particularly enjoy confronting two men, both armed with an array of clubbed metal sticks and I still don't understand why they felt it okay to play there in first place.

The second picture is of a guy I initially ignored because I saw he was outside the boundary but then became annoyed by the incident later on. It's still super close to the boundary so if he digs a divot he might still cause a fielder needless injury. All so this fool can play his out of bounds shot from the exact spot it landed. Considering I have also seen golfers ignore a fielder's request to delay their tee drive for a moment while he retrieved a particularly vigorous boundary shot I find myself maybe more annoyed by golf than ever before even as I have taken up the sport for myself and really really like it. Confounding.

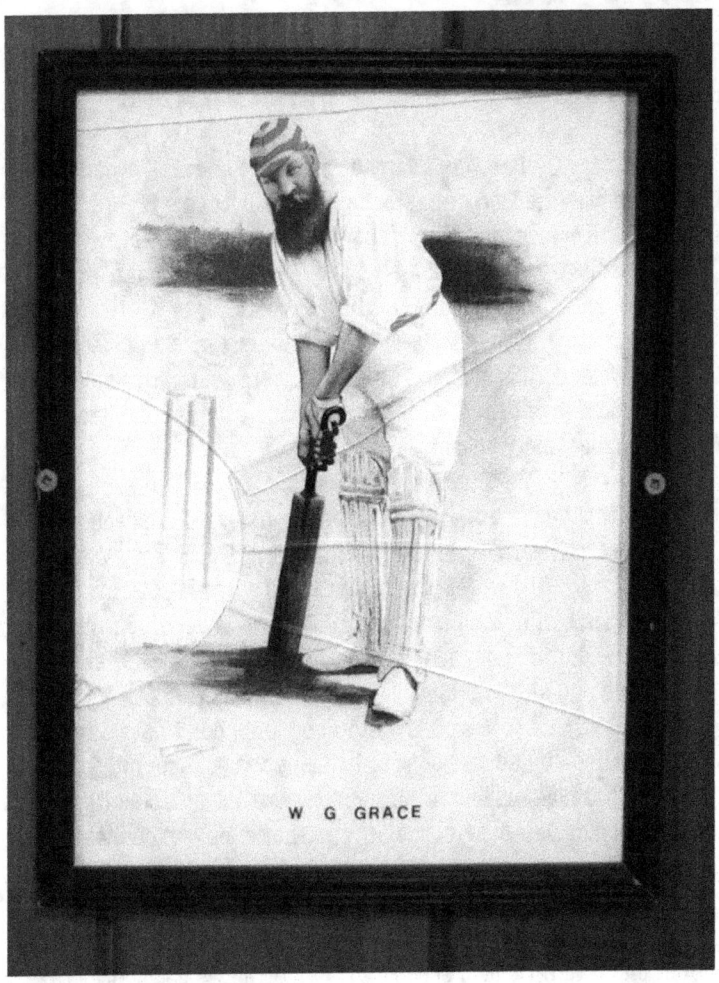

The Face of God

If you've never seen Monty Python's Life of Brian you may not understand the reference. Whaddya mean the face of God?

Before Terry Gilliam was a famous crankpot and Hollywood film director he was the lead animator for Monty Python's Flying Circus. And in all the episodes of the tv show and movies, whenever the God character appeared in the clouds to scold or squash humans, as God sometimes does, Terry Gilliam used an old portrait of WG Grace. A comic alternative to the usual face, intentionally mocking a certain Euro-centric conception of God as a beardy old white guy who sits in the clouds and gives direct orders to humans via stone tablets and burning bushes and whatnot.

Despite this deliberate attempt to be very silly, Gilliam echoes a claim made by the great CLR James that WG Grace is something like a divine figure in the world of cricket, hence why his portrait hangs beside Ranjitsinjhi in the clubhouse at Victoria Park. Given this kind of status I feel it incumbent of me to reiterate my desire to see the glass in this and all the other broken picture frames fixed. I get that something like this costs money and I certainly don't have any. I always assume no one else does either. But someone found CDN$100,000 for tournament prize money and such amounts aren't usually just misplaced down the back of the couch, which means if there is that much available for prizes surely a bit of cash can be found to tidy up the place before the international guests arrive?

Just planting little idea seeds and wondering what might grow. Whatever happens, I'll see you in 2023.

www.ingramcontent.com/pod-product-compliance
Lightning Source LLC
Chambersburg PA
CBHW052323220526
45472CB00001B/242